Digital
Black & White
Photography

THE EXPANDED GUIDE

DAVID TAYLOR

AMMONITE
PRESS

First published 2011 by
Ammonite Press
an imprint of AE Publications Ltd.
166 High Street, Lewes, East Sussex,

Text © AE Publications Ltd.
Illustrative photography © David Taylor
© Copyright in the Work AE Publications Ltd., 2011

ISBN 978-1-906672-91-1

Series Editor: Richard Wiles
Design: Richard Dewing Associates

Typeset in Frutiger
Color reproduction by GMC Reprographics
Printed and bound in China by Hing Yip Printing Co. Ltd.

CONTENTS

Chapter 1	Introduction	8
Chapter 2	Equipment	21
Chapter 3	Understanding Exposure	34
Chapter 4	Composition	54
Chapter 5	Color to Black & White	76
Chapter 6	Special Effects	98
Chapter 7	Projects	138
Chapter 8	Printing	166
	Glossary	186
	Useful web sites	189
	Index	190

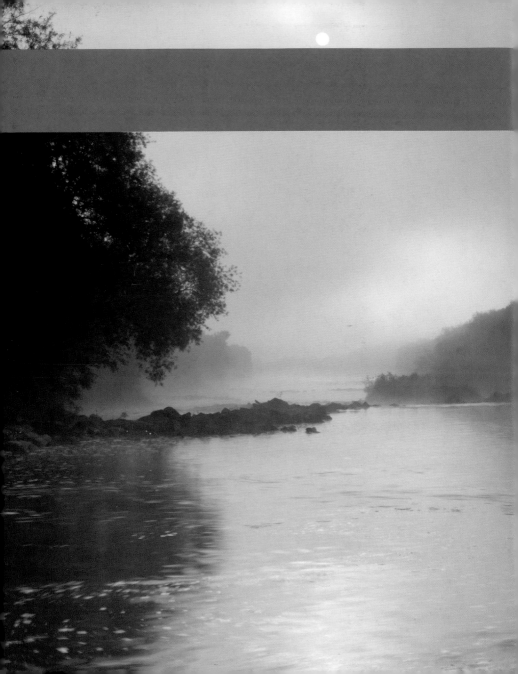

CHAPTER 1 INTRODUCTION

Black & white photography

Creating striking black & white photographs was once the preserve of the expert. Now, with a digital camera and the right software, this art form has never been more accessible.

In 1826, the first ever photograph was created. It was in black & white. The idea of creating a color photograph wasn't too far behind, but for most of the nineteenth century and well into the twentieth, photography was essentially a monochromatic art form.

Black & white photography requires you to interpret the world in a different manner to the way you do when shooting color. A black & white photograph is a less literal representation of the captured scene. Because there are no color cues, tone and contrast become more important as a means of defining the relationship between the various elements of your photograph.

Learning how to see 'beyond' color takes practice, but becomes second nature surprisingly quickly. However, creating a photo is just the start of a creative journey. Black & white photography is a wonderful medium for self-expression. The history of black & white photography since 1826 has been a rich stew of experimentation in style and techniques. In this book we'll explore some of these possibilities. The only problem is that once you start you may find it difficult to stop!

LANDSCAPE
There are no subjects out of bounds to black & white photography. Nor are there any rules to how you should interpret the resulting photo. This photo is a relatively straightforward record of open moorland.

LION (right)
This photograph has been more heavily altered. It has been warm toned and a soft focus effect applied. The original file was just a base to work from.

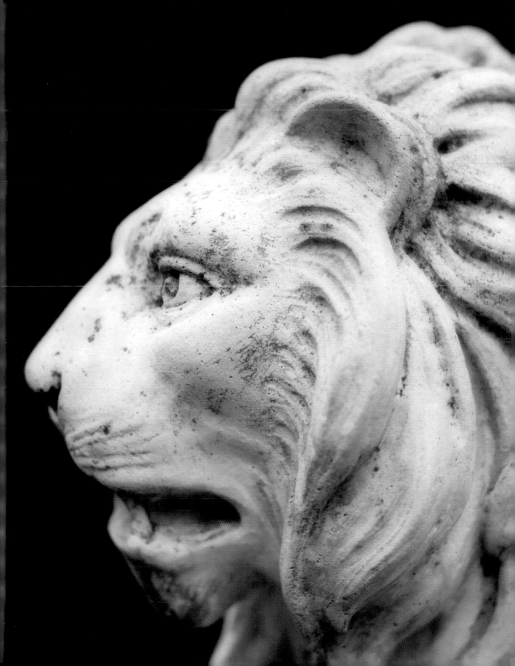

Color

Visible light is just one small part of the spectrum of electromagnetic radiation that extends from gamma rays at one end to radio waves at the other. Light comprises discrete 'packets' of energy known as photons. It is the release of energy as photons strike your camera's digital sensor that causes a photo to form. Visible light also acts as a wave, with a range of wavelengths between 400 nanometers and 700 nanometers (a nanometer is one millionth of a millimeter).

At a wavelength of approximately 400 nanometers, light is perceived as a dark, purple violet. At 450 to 500 nanometers, this violet shades to blue; then as the wavelength increases, the color of perceived light continues through green, yellow, orange, and, at approximately 700 nanometers, reaches red. When relatively even amounts of all the wavelengths of visible light are mixed, light looks white.

We see color by the way that light reacts when it strikes an object. A red apple is red because all of the visible wavelength of light is absorbed by the apple except for the red part of the spectrum. These red wavelengths bounce off the surface of the apple and stimulate the red sensitive part of our vision.

SHINY APPLE
A relatively tiny percentage of the visible wavelengths of light is reflected by an object. In the case of a red apple, it is the wavelengths at approximately 700 nanometers. All the other wavelengths are absorbed.

Tonal values

When a black & white photo is created, the various colors of the subject are transformed into tones of gray. The art of black & photography is controlling what tonal value each color is converted to.

To take the example of a red apple again, when converted to black & white the red will be altered to a mid-gray tone. Green grass will also be converted to a mid-gray tone. If we create a black & white photo of an apple sitting on grass, the two subjects will have similar tonal values. In color, the two subjects are distinctively different. In black & white, it will be hard to distinguish one from the other.

Traditionally, colored filters (see page 31) were used to help change the tonal values

of the subjects in a photo. A colored filter lets through the wavelengths of light similar in color to itself and reduces the strength of those that are dissimilar. If a red filter is used in the example quoted, the apple will lighten in appearance and the grass will darken. The tonal values of both will have diverged, creating a far more interesting photo.

The Black & White conversion tool in Adobe Photoshop (see page 81) can now be used instead of colored filters, though the principle is still the same. A black & white photo is about tones and how they can be adjusted to create the most striking image.

SHADES OF GRAY

Canon 7D, 17–40mm lens (at 17mm), 1/8 sec. at f/14, ISO 200

Converting to black & white means deciding what tone each color will become. In this photo, I wanted the blues of the sky to darken to help define the shape of the clouds. I used the equivalent of a red-orange filter, which also lightened the rocks in the foreground, separating them tonally from the fields behind.

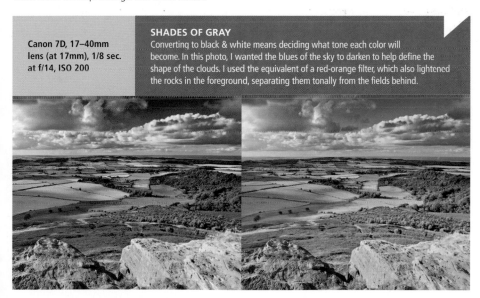

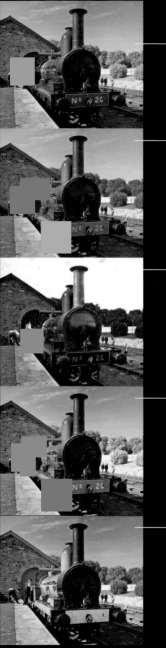

Adjusting the tones

COLOR
The original color photo is vibrant, rich in red, green, and blue. Even though I saw it as a color photo at the time, when I reviewed it afterwards I could see potential for a black & white version.

BLACK & WHITE
Converted to black & white so that all the colors are treated equally, the photo looks flat and dull. The tones are all very similar and the various elements of the picture seem to be merging into one another. It's a black & white photo and that's probably the best you can say about it.

BLUE
For the second attempt at conversion, I lightened the blue tones and darkened the reds. This would be equivalent to using a blue filter. It has made the sky a lot paler and the body of the locomotive much deeper. There's a lot more contrast now, but it's still not what I want.

GREEN
This time I've simulated using a green filter. The foliage, the grass and trees, in the photo has been lightened. The photo is improving, but I still feel that the locomotive itself looks flat and uninspiring.

RED
Finally, I adjusted the reds, simulating the use of a red filter. The sky has darkened and now looks more interesting. The locomotive has more character, too. The red of the body is lighter and stands out from the black areas more. This is the conversion that I'm happiest with.

Previsualization

Your camera is a wonderful device but, no matter how sophisticated the technology inside, it does not know how to create a pleasing photograph. That decision rests with you alone! Before you press the shutter-release button to create a photo, you need to work out what you want the final photo to look like.

In order to do this you need to ask yourself a few questions. How you answer these questions will help you in this previsualization process. Given below are a few such questions, though it is not an exclusive list. As you gain in experience you will find you add questions of your own.

Emotion

What mood or atmosphere do I wish to create? Do I have a simple message that I want convey or will the meaning be more ambiguous? Is the light right at this moment or do I need to return at a different time?

Composition

What should and shouldn't be included in the photo? What lens do I need to use? Will a different viewpoint work better? Should the camera be held vertical or horizontal?

Technique

I have my composition, now how do I technically achieve my aims? Can it be achieved 'in-camera' or will it require editing later? If so, how do I ensure I capture a sufficient tonal range to make the editing process easier? Do I need to use filters?

Why not try...?

The squint test. Cameras cannot record the contrast range we can see. However, squinting can help you assess how a camera would 'see' the scene remarkably accurately. Bright areas will still seem relatively light, but the shadow areas will darken considerably. If you cannot see details in the shadows, it is likely that the contrast range will be too high for the camera to record the full tonal range.

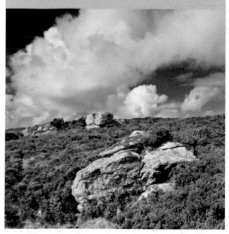

OUTER HEBRIDES
I previsualized this scene as I saw the cloud building up above me. It was only a matter of waiting until the cloud was where I wanted it to be to create the final photo.

Canon 5D, 24mm TS-E lens, 1/25 sec. at f/11, ISO 100

Camera sensors

The digital sensor in your camera is a device for converting photons of light into information that can be used to form a photo. The most common sensor type uses the Bayer system. A Bayer sensor is divided up into a rectangular array of millions of tiny photosensors. These photosensors are arranged into groups of four, one photosensor to record red, one for blue, and two for green. The information from these four photosensors is then combined to produce one pixel in the final digital photo file. It is the number of pixels created this way that determines the resolution of the camera. A sensor able to create 4000 by 3000 pixels (or 12 million) is referred to as a 12 megapixel (or mp) sensor.

Catching Light

A photosensor can be thought of as a receptacle to catch light, in the way that a bucket is used to catch rainwater. The smaller the sensor (as in a cell phone, for example), the smaller the photosensor 'buckets.' This results in a small sensor being unable to capture as much information (or number of photons) at the time of exposure as a bigger sensor with the same resolution. This can have a detrimental effect on the noise *(see page 43)* present in the final photo, the dynamic range *(see page 47)*, and the sensor's low-light sensitivity *(see page 42)*. However, technology is improving and modern small sensors are much improved in this respect in comparison with those from even a few years ago.

BAYER SENSORS
This diagram shows a typical arrangement of photosensors in a Bayer sensor. There are more green photosensors because this arrangement mimics the physiology of the human eye.

From pixels to paper

Ultimately the best way to view a photograph is as a paper print. Theoretically, the greater the number of pixel sensors on a chip the larger and sharper the final print should be *(see chapter 8 for more about making prints)*. However, other factors such as lens quality and photography technique will often determine the maximum print size more than the number of megapixels on the digital sensor.

8-bit versus 16-bit

A bit is the smallest unit of data used by a computer. It is essentially a switch that is either off (0), or on (1). A byte is a string of 8 bits. In binary notation a byte can be used to store numbers from 0 through to 255. This range of values is used to represent colors on devices such as computer monitors.

Each pixel on your monitor requires 3 bytes of color information, one for red, one for green, and the last for blue (shortened to RGB). It is this RGB combination that results in the 16.7 million different colors that your monitor can display (256 x 256 x 256). Black is R:0, G:0, B:0; White is R:255, G:255, B:255. A pure gray tone is an equal combination of red, green, and blue. Mid-gray, for example, has an RGB value of R:127, G:127, B:127.

Digital camera RAW files use 12, 14, or even 16-bits to record color information. In a 16-bit image, two bytes are used to store each RGB value, allowing 65,536 levels of color as opposed to 256. Monitors and printers can't

display this range of colors. However, software that supports 16-bit files can use this extra information 'behind the scenes,' when tonal adjustments to the photo are made. When an 8-bit image is edited, it can quickly suffer from 'posterization' or odd jumps and gaps in the color of the image. This is because the data in the file has been pushed too far. This is less likely to occur in a 16-bit file because of the extra information available. When making tonal adjustments, it is recommended that you begin with a 16-bit file and then convert to 8-bit for storage and printing.

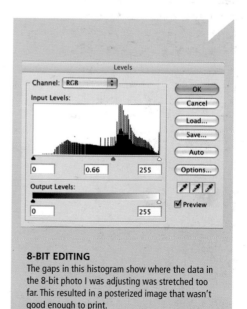

8-BIT EDITING
The gaps in this histogram show where the data in the 8-bit photo I was adjusting was stretched too far. This resulted in a posterized image that wasn't good enough to print.

Saving your photos

There are two photo file formats commonly offered by a camera, JPEG and RAW. Both have strengths and weaknesses, and which you choose will depend on how you use your photos after capture and how much time you are prepared to devote to post-production.

JPEG files

JPEG photo files are compatible with a wide range of software packages. This includes photo editors such as Adobe Photoshop as well as web browsers and word processors.

JPEG files are typically smaller than RAW files and so use less space on a memory card or hard drive. This is achieved by a form of compression that reduces the detail in the photo, lowering the photo quality. How much the quality is lowered is determined by the compression level set on your camera or photo editor. Once a JPEG file has been saved, any loss in quality due to the level of compression used cannot be recovered.

One drawback of shooting JPEG is that the file format only supports 8-bit color. Any subsequent alteration you make to your photo will degrade the quality more quickly than if you were editing a RAW file.

As a rule, shooting black & white in-camera is only an option if you are using the JPEG file format. A RAW file is always saved in full color. One compromise that some cameras allow is to shoot RAW+JPEG. This option will fill your memory card more quickly, since two files are saved for each exposure. However, this will allow you to view the photo in black & white at the time of capture and still have a high-quality file suitable for post-production.

RAW Files

When a JPEG file is saved by your camera, the photo has generally been processed according to a series of user-defined options. These options typically include settings such as contrast, color saturation, and sharpness.

ARTIFACTS
This photo was saved at a quality setting of 0 and so had maximum compression applied. This has resulted in a loss of fine detail, as shown in the close-up on the right.

Canon 7D, 50mm lens, 1/60 sec. at f/2.2, ISO 100

CAMERA RAW
The dialog box shown when importing RAW files directly into Adobe Photoshop.

A saved JPEG is 'baked' and ready to use immediately. In contrast, a RAW file is all the data captured by the camera sensor without any processing applied. If a JPEG is the finished meal, the RAW file is the ingredients you need to make your own.

RAW files need to be converted to a more usable file type, either by using the software supplied with your camera or a third-party photo editor. This is not a quick process and so you must be prepared to allocate time for post-production when shooting RAW. There is also no universally used RAW standard. A RAW file from one model of camera is not necessarily the same as that produced by a different model, even when both cameras are made by the same manufacturer!

These are the disadvantages to shooting RAW. However, the advantages more than make up for any inconvenience. A RAW file is

a 'digital negative,' and is the starting point for the creative interpretation of your photos using your digital 'lightroom.' The alterations you can make to a RAW file are far in excess of the options that are available on the menu of your camera. Also, the color data in a RAW file is saved using 12- or 14-bit values, so there is more leeway for post-production alteration than found with JPEG files.

Why not try...?

Converting your raw files to the DNG format. DNG is an open raw format developed by Adobe Systems. Because it is not tied to one particular camera system, it is more widely recognized by photo editing software and operating systems than proprietary camera raw. See page 189 for Adobe's website URL.

Theatrical light

Landscape photography is at its most powerful when there is an element of drama to the weather. Unfortunately, this does sometimes involve suffering for your art. This photo came after a day spent trudging around the English Cheviot Hills in pouring rain. I was ready to give up for the day and had begun to walk downhill back to the car. Halfway down, the clouds broke and sunlight flooded the valley in front of me. I scrabbled to get the camera set up and record the scene before the clouds closed in again. The lesson I learnt that day is to be prepared for changes in the weather and not to give up too quickly!

COLLEGE VALLEY, NORTHUMBERLAND, UNITED KINGDOM
Canon 5D, 50mm lens, 1/25 sec. at f/11, ISO 100

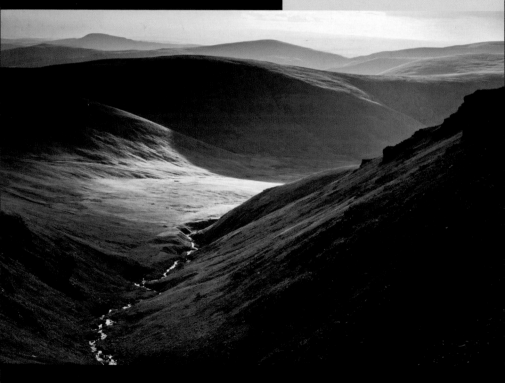

The prepared mind

Travel photography inevitably involves certain compromises. Because time is limited it is often not possible to return to a location over and over until the conditions are right for that perfect shot. On a trip to Belfast, Northern Ireland, I had the luxury of a day to scout around potential locations for an evening of photography. During that day I worked out a number of compositions I wanted to create. When evening came I was able to work quickly and maximize the numbers of shots I could make in the limited time I had available.

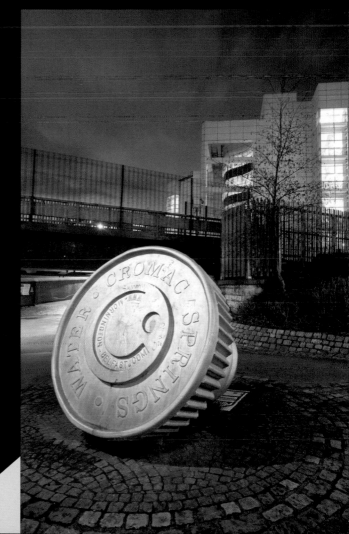

LAGANSIDE, BELFAST, NORTHERN IRELAND
Canon 1DS MkII, 17–40mm lens (at 21mm), 30 sec. at f/13, ISO 100

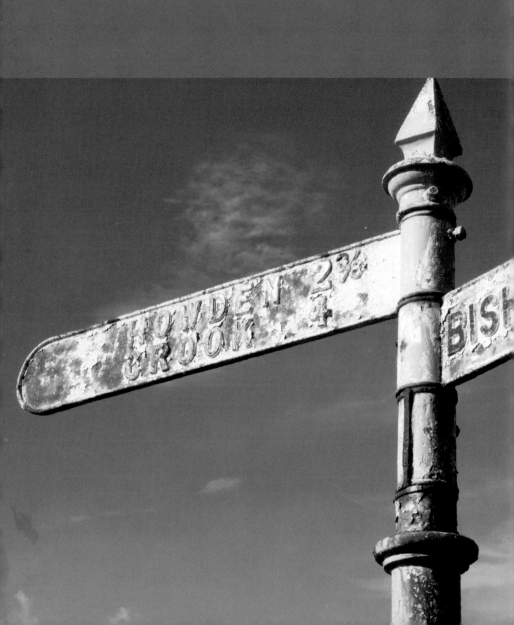

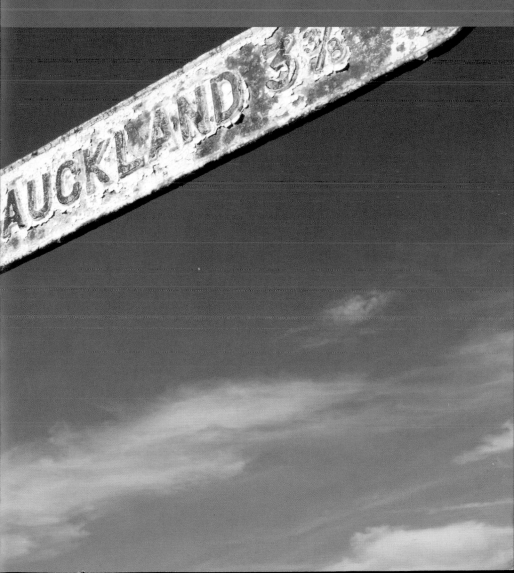

CHAPTER 2 EQUIPMENT

Equipment

What camera equipment you use is largely a matter of taste and budget. This chapter is a guide to the various options available. However, ultimately it is not the camera that makes the photos, it is the person who presses the button. That will always be the case no matter how sophisticated the technology becomes.

TOY CAMERA
This was shot on a plastic 'Holga' film camera that cost me less than $32 (£20). Cameras don't need to be expensive for you to have fun and make creative photos.

DSLR

The digital single-lens reflex (or DSLR) camera is the most flexible option if you plan to expand the capabilities of your photographic equipment. A DSLR is usually one part of a camera system that includes lenses and flashguns made either by the original camera manufacturer or a third party. Typically, the accessories for one camera system will not be compatible with those from another. This makes it is easy to get 'locked' into a camera system and expensive to change if you wish to switch to a different brand.

Using your DSLR

When you look through the viewfinder of a DSLR you see precisely what the camera sees, regardless of the lens used. This makes them ideal for precise composition. The price to be paid for this is a complex system involving a mirror and a pentaprism that folds the light coming through the lens and directs it to the viewfinder. When the shutter-release button is pressed, the mirror swings up to let light through to the shutter behind. After exposure, the mirror drops back into place. During this process, the viewfinder is temporarily blacked out. This mechanism is bulky and so DSLRs are often large and heavy items of equipment.

Recent advances in technology have seen DSLRs that eschew the mirror in favor of a 'liveview' viewfinder with an electronic display (or Electronic ViewFinder—EVF). This has helped to shrink the size of some DSLRs to almost compact proportions.

Another feature of the DSLR is the level of control you have over all aspects of the camera's functions. Manual exposure and manual focus on a DSLR will allow you take full creative control of your photo making. The ability to shoot RAW files, common to all DSLRs, *(see page 16)* gives you further scope for creativity after the photo has been exposed.

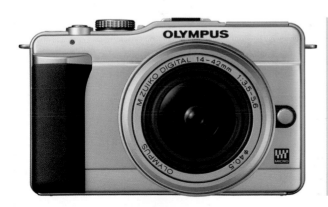

OLYMPUS E-PL1
One of the new breed of compact DSLRs that does not use a mirror system, enabling the camera to be made smaller than conventional designs.

Compact cameras

As the name suggests, a compact is a small camera suitable for carrying in a small case or pocket. Although many compacts have a zoom lens, this lens cannot be removed (an adapter is an option available for some compacts to extend the zoom range). This makes compact cameras far less expandable than a DSLR, so you may quickly outgrow a compact camera as your photography develops. Compact cameras also tend to be less well specified than DLSRs. The ability to shoot RAW is generally only an option on more expensive models.

Using your compact camera

Despite these limitations, a compact camera—thanks to its size and weight—makes an ideal 'carry-around' camera. Indeed, many professional photographers use compact cameras as pocket-sized visual 'notebooks.' Composition on a compact is typically done by using the rear LCD screen, though some compacts also have an optical finder either built-in or available as an optional extra. In bright conditions the LCD screen is often difficult to see. There is a variety of add-on screen shades available for most cameras that may be useful in these situations.

Bridge Cameras

Falling somewhere between compacts and DSLRs in size, weight and expense are 'bridge' cameras. These cameras are visually similar to DSLRs but do not have a detachable lens. They usually have a viewfinder, but instead of looking through the lens you look at an EVF. Bridge cameras tend to be very well specified, and though less expandable than a DSLR, are often able to take external flashguns and have a filter thread on the lens that enables you to use filters *(see page 30)*.

MURAL
A compact camera is very useful as a visual 'notebook' when out for a walk. Ideas for future compositions can be explored quickly and easily without the need to constantly carry around bulky camera equipment.

Canon G10, lens at 8mm, 1/80 sec. at f/5, ISO 80

Cell phones

The ubiquity of the cell phone has had a marked effect on photography. Now anyone with a modern cell phone also has a remarkably capable camera at his or her fingertips. The digital sensor in cell phones is generally even smaller than those found in compact cameras and so photo quality is often compromised *(see page 14)*, but this is more than made up by the sheer portability of the phone. This has led to the rise of a 'citizens' journalism,' in which events that once would have been missed are immediately captured for posterity by people on their cell phones.

Using your cell phone

One of the big drawbacks with a cell phone is that the photos captured are stored as JPEGs, often heavily compressed to reduce their file size *(see page 16)*. This will make it more difficult to edit the photos afterwards without further loss of quality. However, most cell phones can apply a variety of effects to a photo at the time of capture, reducing the need for further manipulation. The two most common effects are monochrome, where the photo is converted to a series of gray tones, and sepia *(see page 108)*.

Smart phones

The latest generation of cell phones, most notably the Apple iPhone range, can run downloadable software known as an app (short for application). There are various photography apps available for smart phones

that allow more sophisticated black & white conversions than those possible with a standard cell phone.

Why not try...?

VINT B&W for Apple iPhone or Camera Illusion for Android OS phones.

SAND PATTERNS
This photo was stored on my cell phone for several months before I realized its potential for conversion to black & white. I now make it a habit to regularly review and edit anything created on my phone!

Vodaphone V810 cell phone, exposure data not recorded

Lenses

The focal length of a lens is the distance in millimeters from the optical center of the lens to the focal plane when a subject at infinity is in focus. The focal plane is where the sensor in your camera is located. Lenses with a fixed focal length are known as 'primes.' Lenses where the focal length can be changed are referred to as 'zoom' lenses.

The angle of view of a lens is the angular extent of the image projected by the lens and recorded by the sensor in your camera. The angle of view is dependent on the focal length of a lens and on the size of the sensor. A wide-angle lens, as the name suggests, captures a wide angle of view. This results in elements of the picture appearing spatially farther apart. The longer the focal length, the smaller the angle of view becomes, but the more the image is magnified, bringing your subject 'closer' to you. Longer lenses are generally referred to as telephotos.

Extreme wide-angle lenses (14–20mm)

These lenses have a huge angle of coverage, though the resulting images can look decidedly unnatural. Straight lines become curved and

WIDE-ANGLE
An example of the sense of space it is possible to create with a wide-angle lens.

Canon 1DS MkII, 17–40mm lens (at 17mm), 1/8 sec. at f/14, ISO 100

TELEPHOTO
The longer the lens the more 'stacked' the elements of your photo will look. The buildings in this photo look right on top of each other, though in reality they are spatially distant.

Canon 7D, 70–200mm lens (at 120mm), 1/400 sec. at f/8, ISO 100

the spatial relationships between elements of the scene are exceptionally distorted. It's not recommended to use an extreme wide-angle lens as a portrait lens unless for effect.

Wide-angle lenses (24–35mm)

Perspective is less distorted than the extreme wide-angle lenses, but can still look unnatural, particularly when creating images of people. Landscape photographers commonly use wide-angle lenses to create a sense of space, as shown in the photo, left.

Standard lenses (50–70mm)

A standard lens is one that is generally thought to produce an image that most closely resembles how we perceive the world. Perspective looks natural and spatial relationships are normal.

Telephoto (85–200mm)

Perspective is more compressed resulting in objects in a scene looking closer together, and the angle of view is small. Telephoto lenses are useful when single objects at a distance need to be isolated from their surroundings.

Extreme telephoto (300mm–greater)

Perspective becomes very compressed and objects that aren't necessarily close spatially can look 'stacked' together. A very narrow angle of view means that objects are very isolated from their background and thus become the most important (and often the only) element in the image.

Note: *All the focal lengths quoted above are '35mm equivalent.'*

Scanners

The most common scanner available is the flatbed scanner. These come in many forms, often as one part of a printer and fax system. The most useful flatbed scanners are those with a built-in light-hood, which is used when scanning slides or negatives. A light-hood can also be used to create digital photograms *(see page 116)*. See opposite for tips on what to consider when buying a flatbed scanner.

Less common are dedicated slide scanners. These will only scan slides or negatives and cannot be used for documents. Slide scanners able to scan 35mm film are still being produced at the time of writing, though the choice is now limited. Dedicated slide scanners will generally produce a higher quality result compared to a flatbed scanner.

The choice of slide scanners is even smaller still if you have medium format slides or negatives to scan. The Nikon Super Coolscan 9000-ED is the only medium format slide scanner still in production, though others such as the Minolta Scan Multi Pro can sometimes be found secondhand.

The most frustrating aspect of scanning slides is dust. Although dust specks are easily cloned out using Photoshop it can be a tedious process particularly if the slide is old and hasn't been cared for. Some slide scanners have automatic dust removal systems, such as ICE, though the extra processing involved will increase the scanning time.

Color bit depth

The higher the bit depth of your scanner the more accurate the color information in the resulting scan will be *(see page 15)*. For scanning slides and negatives, a bit scanner with a depth of 36 or 48 is preferable.

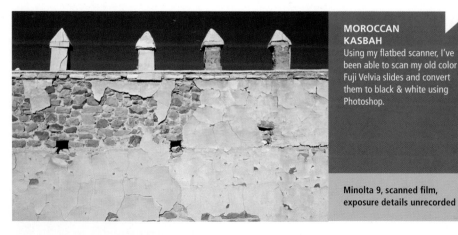

MOROCCAN KASBAH
Using my flatbed scanner, I've been able to scan my old color Fuji Velvia slides and convert them to black & white using Photoshop.

Minolta 9, scanned film, exposure details unrecorded

Connection

USB 2.0 is the current standard and most modern PCs will have a USB 2.0 port. Some scanners also use Firewire or SCSI connections. These are just as fast as a USB 2.0 connection, though not all PCs have the ability to connect to these devices without the installation of the relevant interface board.

Resolution

The optical resolution of the scanner will determine how much detail the scanner can extract from your transparency or negative. Some scanners boast an impressively high resolution, achieved through software interpolation. However, this is not the same as optical resolution and the results are generally inferior. For scanning slides an optical resolution of 1200 dpi or higher is the minimum you should consider.

D-max

Also known as dynamic range *(see page 47)*, d-max is a measure of the tonal range the scanner can resolve. To scan slides or negatives, a scanner should have a d-max value of at least 3.4.

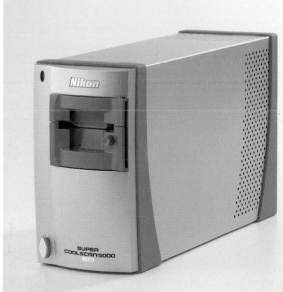

Why not try...?
Third-party slide scanning software often has more features than that supplied with your scanner. 'Vuescan' by www.hamrick.com is a good and inexpensive alternative, with a 30-day trial version available for its appraisal.

NIKON SUPER COOLSCAN 5000-ED
The 35mm cousin of the 9000-ED, this dedicated slide scanner boasts an optical resolution of 4000 dpi and 48-bit color.

Using filters

A filter is a piece of glass or plastic placed in front of your camera lens that will have an effect on the light passing through it. When shooting black & white film, colored filters will alter the tonal values of the resulting photograph. The effects these filters have can now be replicated when converting color photos to black & white using Photoshop. In some respects this is a good thing, since adding a filter to the front of your lens inevitably results in some loss of quality in the final photograph. The more filters you use, the greater this loss will be.

However, filters still have their uses and if you are shooting black & white JPEGs, colored filters will have just as much effect as if you were shooting film. Other filters to consider using are neutral-density, polarizers, and graduated types.

Attaching filters

There are several ways to attach a filter to your lens. Circular filters have a thread that screws directly onto the front of the lens. These filters are generally inexpensive, though they do have the disadvantage that there is no standard filter thread size. You may find that you have to buy the same type of filter many times over to fit the different lenses in your collection. One solution is to buy adapter rings that will allow you to attach one filter to many different lenses. However, using too small a filter on a lens will cause vignetting. Another disadvantage is that filters such as neutral-density graduates are less

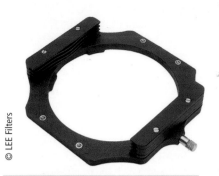

© LEE Filters

LEE FILTERS
The LEE Foundation Kit filter holder allows you to stack up to three different filters at any one time.

easily adjusted when they are in circular form.

Another method of attaching a filter to your lens is to use a filter holder system. Filters designed for use in a system are usually square or rectangular and are designed to slide into slots in the holder.

There are several manufacturers of filter holder systems, such as Cokin and the British company LEE. The range of filters available for both systems is extensive and is further increased by compatible filters produced by other manufacturers. Adapter rings allow you to attach the filter holder to multiple lenses. Vignetting caused by smaller filter holders can be a problem on extreme wide-angle lenses, so it pays to use the largest (and therefore most expensive) system that your budget will allow.

Colored filters

If you choose to shoot black & white photos in-camera, the most useful set of filters you can own are red, orange, yellow, green, and blue colored filters. These work by blocking certain wavelengths of light reaching the digital sensor in your camera. The blocked color will darken considerably. Conversely, similar colors to the filter color will lighten in tone. Red, orange, and yellow are useful for landscape photographers, since they will darken blue skies and help define the shape of clouds (red most dramatically,

followed by orange, then yellow). Green filters are often used in portraiture to help produce pleasing skin tones as well as lightening foliage.

Because colored filters block certain wavelengths of light, there will inevitably be a certain amount of light loss. Auto-exposure will compensate for this but you will need to be aware of these changes if you use manual exposure. The compensation factor required should be provided with the filter when you buy it, or available as a fact sheet on the filter manufacturer's website.

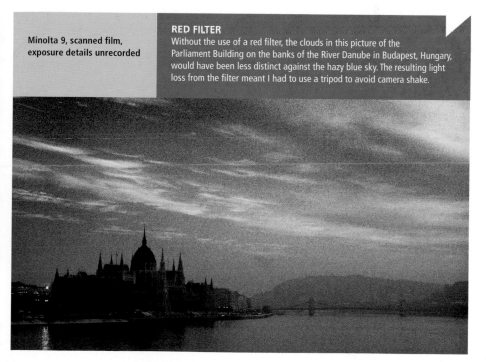

Minolta 9, scanned film, exposure details unrecorded

RED FILTER
Without the use of a red filter, the clouds in this picture of the Parliament Building on the banks of the River Danube in Budapest, Hungary, would have been less distinct against the hazy blue sky. The resulting light loss from the filter meant I had to use a tripod to avoid camera shake.

Polarizing filters

The classic use for a polarizing filter is to deepen the blue of a sky. This is most effective when the polarizer is pointed at 90° to the sun. The effect lessens as you move away from this angle. If there are clouds in the sky, the polarizing effect will help to increase the contrast between the clouds and the sky.

Another use for the polarizing filter is to vary the amount of light reflected from non-metallic surfaces. This applies to a wide-range of surfaces from water, to paint, to wet leaves. The optimum angle for this effect is when the polarizer is about 35° to the reflective surface.

Polarizing filters can be bought to screw directly onto your camera lens, or to fit onto a filter system holder. The front element of a polarizing filter is designed to rotate through 360°. Rotating the polarizer allows you to vary the strength of the effect. At maximum polarization, you will find that skies can begin to turn almost black. If you were shooting in color, this effect could look decidedly unnatural, but it is a useful way to add a touch of drama to a sky in a black & white photo.

There are two types of polarizers, circular and linear. This does not refer to the shape, but rather to the properties of the filter. Linear polarizers are only suitable for manual focus

Canon 7D, 17–40mm lens (at 17mm), 1/15 sec. at f/13, ISO 200

VIEWPOINT
Strong sunlight with a scattering of clouds to add interest to the sky made this an ideal scene to use a polarizer. The polarizer was set to maximum to deepen the tones in the sky as much as possible.

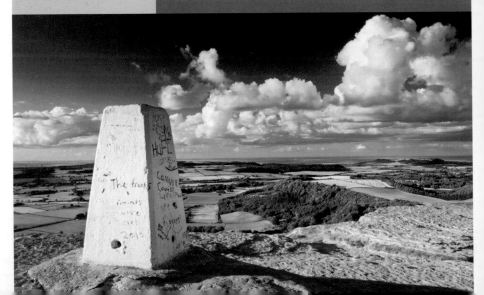

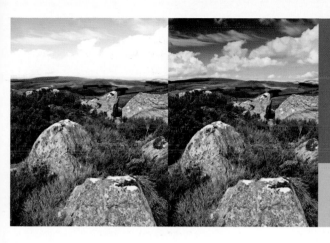

cameras. If your camera has autofocus, you should use a circular polarizer. A polarizer will reduce the amount of light reaching the sensor in your camera. It can therefore be used as a neutral density filter. Your camera should compensate for this light loss but if you are shooting in manual exposure mode you will need to increase the exposure by 1.5 to 2 stops.

Neutral density filters

There are occasions when the base ISO (see page 42) of your camera may be too high to achieve a desired shutter speed and aperture combination. For example, trying to use a slow shutter speed and a large aperture without overexposure is almost impossible in direct, bright sunlight.

A neutral density filter is partially opaque and cuts down the intensity of the light passing through it. This will allow you to use longer shutter speeds or larger apertures as desired.

They are made in a variety of strengths, from 1 stop to 10 and are available either as a circular screw-in type or sized to fit into a filter holder.

ND-graduate filters

One of the problems frequently encountered when creating landscape photos is controlling the contrast between the sky and foreground. This problem is particularly acute when the foreground is unlit. Exposing for the sky will result in an underexposed foreground. Exposing for the foreground will cause the sky to burn out.

ND-graduate filters are used to balance these two requirements. Like neutral density filters, they come in a variety of strengths. The top half of the filter is slightly opaque, shading down to a transparent bottom half. The stronger the filter, the more opaque the top half. The greater the exposure difference between sky and foreground, the stronger the ND-graduate filter you would use.

CHAPTER 3 UNDERSTANDING EXPOSURE

Understanding exposure

The sensor in your camera requires a certain amount of light to capture an image. Understanding and controlling this process is an important aspect of creative photography.

The word photography is derived from the Ancient Greek words φως (phos or light) and γραφω (graphō, or I write). Photography is 'writing with light.' If the art of writing is telling a story well, the same is true of photography. Instead of choosing words for our story, we choose the amount and quality of light that is suitable for the photo we want to create. Light has many qualities; it can be hard or soft, direct or ambient, warm or cool. There is an old adage that there is no bad light, only bad photography. Learning to recognize and successfully control the various characteristics of light is one part of the journey of becoming a photographer.

We control the amount of light entering the camera with two basic controls, aperture and shutter speed. The meter in your camera will guide you as to how they should be used, though it is only a guide. The decision, as much a part of the creative process as composition, should ultimately be yours.

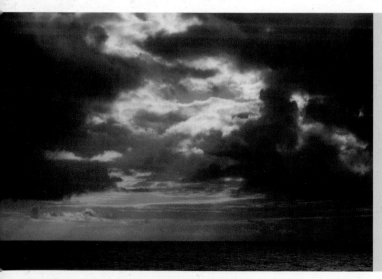

CLOUDSCAPES
Two very different photos of coastal subjects. The photo on the *facing page* is light and airy. This photo is far more brooding and dramatic. The difference is in the quality of the light.

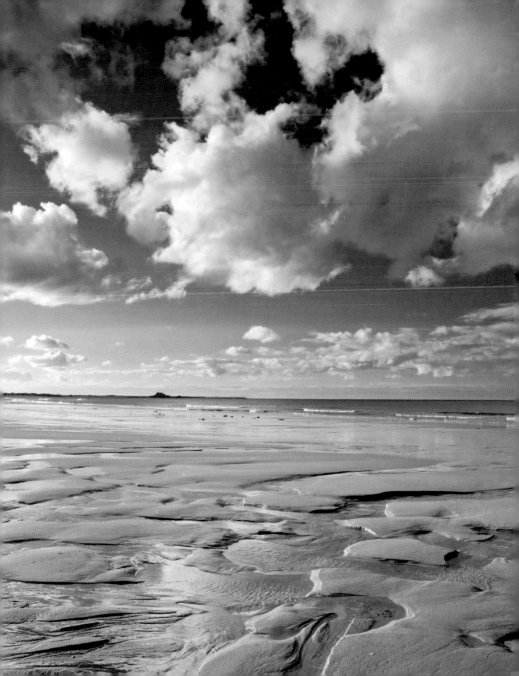

Aperture

The aperture of a lens is the opening through which light passes on its way to the digital sensor. The size of the aperture on all but the simplest of cameras can be adjusted from 'maximum,' when the aperture is as open as is physically possible, to 'minimum,' when the aperture is at its smallest.

The aperture is reduced or enlarged in precise units known as 'f-stops.' The smaller the number after the f/ mark, the wider the aperture and the larger the number after the f/ mark, the smaller the aperture.

The range of apertures available varies between lens models. Typically zoom lenses have relatively small maximum apertures in comparison to primes. If a zoom has a large maximum aperture, it will either be very heavy or very expensive, and more often than not, it will be both.

A typical f-stop range on a camera lens is:
f/2.8 – f/4 – f/5.6 – f/8 – f/11 – f/16 – f/22

There is a precise relationship between each f-stop value and the values on either side of it. Moving from left to right, each f-stop allows half as much light through to the sensor as the f-stop that precedes it. Or, moving from right to left, each f-stop allows twice as much light through to the sensor as the previous f-stop.

Because less light is admitted through the aperture as it is stopped down, the shutter speed must be lengthened to compensate.

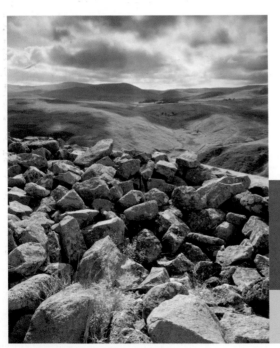

IRON-AGE FORT
Stopping a lens down increases the depth of field. In order to extend sharpness from the foreground to the horizon in this photograph of an iron-age fort in Ingram Valley, Northumberland, I used a small aperture.

Canon 1DS MkII, 17–40mm lens (at 27mm), 1/50 sec. at f/16, ISO 100

Depth of field

Changing the aperture has a noticeable effect on the photo. As the aperture is made smaller, a zone of sharpness extends out from the point of focus. This effect is known as 'depth of field.' The amount of depth of field achievable is dependent on several factors: the lens aperture used, the focal length of the lens, and the camera-to-subject distance. Depth of field always extends farther back from the point of focus than in front.

The longer the focal length of a lens, the less depth of field there will be for a given aperture. With a wide-angle lens, it is often relatively easy to achieve front-to-back sharpness with a moderately small aperture. This becomes almost impossible with a long lens, even when it is stopped down to the smallest aperture. Depth of field also diminishes the closer the camera-to-subject distance. Macro photography, with its very small camera-to-subject distances, often involves very shallow depth of field and necessitates an accurate focusing technique.

Deep depth of field is often used by landscape photographers to create front-to-back sharpness. Maximum depth of field is achieved by setting the focus point to the hyperfocal distance. This is the closest distance a lens, at a given aperture, can be focused and have depth of field extend out to infinity. Any object from the hyperfocal distance to half that distance should also be acceptably sharp.

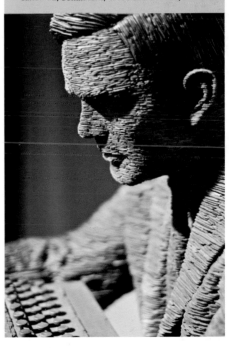

FATHER OF COMPUTING
I was unable to set up a tripod to shoot this photo of the Alan Turing sculpture at Bletchley Park, Buckinghamshire, United Kingdom. In order to maintain a reasonable shutter speed, I set the lens to the maximum aperture and increased the ISO *(see page 42)*. Because the depth of field was so small, my focusing had to be very precise.

Canon 7D, 50mm lens, 1/160 sec. at f/1.4, ISO 800

Why not try...?
The free hyperfocal distance calculator available from http://www.dofmaster.com

Shutter Speed

The shutter speed of a camera is the duration of time that the shutter remains open, exposing the digital sensor to light. The typical range of shutter speeds on a DSLR runs from 30 sec. up to 1/8000 of a second (compact cameras tend to have a smaller range, typically omitting any speed longer than a second). This range of different shutter speeds allows a variety of different creative interpretations of a scene.

As with apertures, the difference between each consecutive shutter speed is also known as a stop. For example, there is a one-stop difference between a shutter speed of 1/15 and 1/30 of a second (some cameras will allow changes in half or thirds of a stop). As you decrease the amount of time the shutter is open,

each stop difference represents a halving of the amount of light reaching the sensor. A shutter speed of 1/30 of a second will allow half as much light through to the sensor as 1/15 of a second.

If this sounds familiar, then there's good reason. A stop isn't a measurement of time or aperture size, it's a measurement of light. There is a reciprocal relationship between shutter speed and aperture. To maintain the same exposure when using different shutter speeds, the size of the aperture would also have to be altered.

The photograph below was shot at f/11 at 1/60 second. From the table you can see that other combinations of aperture and shutter speed could have been used to achieve the same exposure.

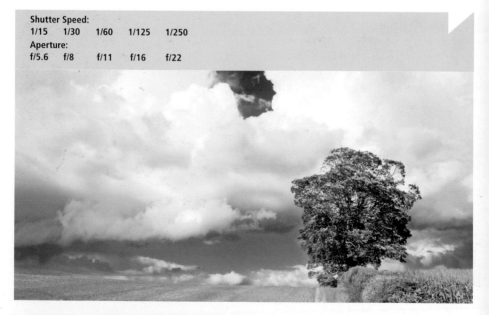

Shutter Speed:				
1/15	1/30	1/60	1/125	1/250
Aperture:				
f/5.6	f/8	f/11	f/16	f/22

Long and Short Exposures

With a static subject, any shutter speed will be suitable. The only limitation would be that a lengthy shutter speed might cause camera shake if you are handholding the camera. As soon as your subject begins to move, the shutter speed you choose will affect the success, or not, of your photo.

The faster your subject is moving, the faster the shutter speed will need to be if you want to 'freeze' the action. A car traveling at 30mph would require a shutter speed of approximately 1/1000 of a second if you wanted a sharp result. The faster the car, the more you'd need to increase the shutter speed. If light levels are low, the more difficult this speed will be to achieve, and to compensate you would need to use your lens at its maximum aperture or increase the ISO (see page 42).

Another creative use of shutter speeds is to suggest movement through blur. Any movement that occurs during a long shutter speed will record as a blur. The faster the subject is moving, or the longer the shutter is open, the more blurred and indistinct the subject will become.

If your camera has a bulb mode, it is possible to lock the shutter open for any length of time, so long as the battery holds out! In bright conditions, it might be impossible to achieve a low enough shutter speed for the desired effect. In this instance, you would need to add an ND filter to the front of the lens (see page 33).

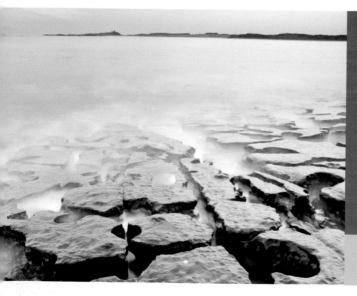

TIDAL WATER
I wanted to record the waves lapping over this rocky shore. The shutter speed was long because the sun had set and I needed a small aperture for maximum depth of field. This has had the effect of rendering the waves as a misty blur.

Canon 5D, 28mm lens, 20 sec. at f/20, ISO 100

ISO

In photography, ISO is the method of measuring the sensitivity to light of the digital sensor. The higher the ISO number, the more sensitive to light the digital sensor is. When ISO is increased, the signal from the sensor is amplified. However, this also amplifies the effect on your photo of background electrical noise caused by the camera's circuitry. Modern sensor designs are increasingly able to circumvent these problems and so reduce noise, but a low ISO photo will always be less noisy than a high ISO photo.

What ISO value you choose will be dependant on the lighting conditions and the nature of the subject you are trying to capture.

Low ISO values (50–800 ISO)

Noise is virtually absent at these speeds, so in terms of ultimate photo quality, a low ISO would be the preferred choice. However, particularly in low-light situations, a low ISO value will mean that a longer shutter speed or wider aperture will be required. This may result in 'camera-shake' or less than the required depth of field to ensure that your subject is sharp.

Mid-range ISO values (800–1600 ISO)

Noise starts to become noticeable at these speeds. You may feel that increased noise may be an acceptable compromise to make in order to keep shutter speeds relatively high for 'freezing action' or to use a small aperture for increased depth of field.

High ISO values (1600 and above)

Noise becomes dominant. High ISO values are not recommended if image quality is in any way important. However, you will have increased flexibility in terms of your choice of shutter speed and aperture combination. If it means the difference between capturing a photo or not, then a grainy photo is better than none at all.

DETAIL
By increasing the ISO on my camera to its maximum of 1600, I was able to hold the camera steady by hand. However, noise has reduced the level of detail quite drastically.

Canon G10, lens at 6.1mm, 1/8 sec. at f/2.8, ISO 1600

Noise

Digital noise is seen as variations in brightness and color in your photos, making them look mottled or blotchy. It is particularly noticeable in large areas of continuous color such as clear sky. How noisy your photos are will be dependent on the size of the sensor in your camera. Generally, at a given number of megapixels, the bigger the sensor, the more controlled noise will be *(see page 14)*.

Causes of noise

There are several ways in which noise can become a problem. Increasing the ISO is one way. Noise can also be caused by heat. This can be a problem with long shutter speeds. The longer the shutter speed, the more the sensor will heat up.

If your camera has the facility to shoot photos longer than one second, it will usually have a menu option to reduce this noise. When selected, the camera will expose twice. The first exposure to create your photo, and then, without firing the shutter, a second exposure is made for the same length of time as the first. From this 'dark frame' the camera can work out where noise is a problem and use this information to 'subtract' the noise. The one big drawback with using this method is that it doubles the length of time needed to make a photo.

Reducing noise

Digital noise is less aesthetically pleasing than film grain *(see page 104)*, since it

tends to be less random and more 'mechanical' in appearance. It often takes the form of distinctive vertical or horizontal banding. This noise can be removed or reduced after capture by using noise reduction software. There is a variety of third-party plug-ins that can be run from Photoshop. These plug-ins are often able to distinguish the type of noise created by a particular camera sensor and so remove noise more effectively.

Why not try...?

Noise Ninja noise reduction software for Windows and Mac. It's available as both a Photoshop plug-in and as a standalone application.
www.picturecode.com

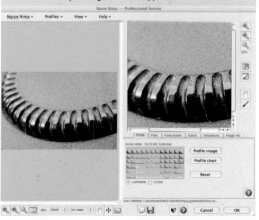

NOISE NINJA
The Noise Ninja dialog box on an Apple Mac.

Reflective metering

All in-camera metering modes use reflective readings to establish exposure. This method of metering measures the amount of light reflected by the scene back to the camera. Reflective metering is based on the assumption that an average scene will reflect 18% of the light falling on it. This is equivalent to an overall tonal value of mid-gray. Grass and stone are good examples of real-world subjects that equate to mid-gray.

However, not all scenes have an average distribution of tones and reflective meters can be fooled by scenes that differ from this ideal. A darker-than-average scene will generally cause a reflective meter to overexpose, a lighter-than-average scene can cause underexposure. In both instances, the error is due to the exposure meter trying to create an overall tonal value equivalent to mid-gray.

The names and number of metering modes vary between camera models. Which you use will be determined by how much or how little of the scene before you that you want to meter and how the results are interpreted.

Multi-segment metering

This method of metering has a number of different names, such as matrix or evaluative, though essentially the principle is the same. The scene to be metered is divided into a number of zones and the camera measures the light in each zone separately. The final exposure is a combination of the exposures from each zone calculated, depending on a number of factors.

One of the factors often taken into account is the focus-point, with the exposure being biased to the zone in which the focus point

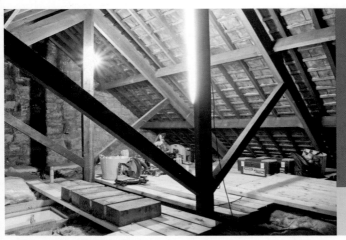

ATTIC CONVERSION
By using the spot meter on my camera I was able to determine that the contrast range of this scene was greater than my camera could cope with. The final exposure was calculated by metering from the top of the bricks on the left of the picture, with the knowledge that there would be little recorded detail in the shadow areas.

Canon 7D, 17–40mm lens (at 17mm), 30 sec. at f/11, ISO 100

falls. Multi-segment metering is generally very accurate and is usually the default in-camera metering mode.

Center-weighted metering

The use of center-weighted metering in cameras pre-dates multi-segment metering and is less sophisticated. In use, the light levels of the entire scene are measured, but the exposure is biased toward the center. This bias varies between camera models, but typically 60–80% of the exposure is determined by the light levels at the center of the scene.

Spot metering

Using the spot-metering mode on your camera allows you to very accurately measure the exposure needed for specific areas of a scene. The metering area is generally somewhere between 1% and 5% of the viewfinder. Usually the spot metering area is in the center of the viewfinder, though some camera systems allow you to move it around the viewfinder, linking it to the focus point.

An important benefit of using the spot meter is helping you determine the dynamic range (see page 47) of a scene. You do this by measuring the exposures needed for both the highlights and the shadow area. If the difference between the two exposure readings is too wide, you will know

immediately that the camera will not be able to record the scene as you see it. To remedy this, you will either need additional lighting to lighten the shadow areas, or to be aware that some compromise in the final exposure will be needed. Generally it is better to lose detail in the shadow areas than the highlights, though of course the creative decision will be yours.

Incident metering

Handheld meters (except handheld spot meters) measure the light falling onto the scene and are therefore not affected by the reflectivity of your subject. Used well, incident meters are usually more accurate than reflective meters. Incident meters are held in front of the subject, with the light-reading mechanism pointing toward the camera. The resulting meter reading can then be set on the camera in manual mode. The one drawback with incident meters is when the subject is some distance from the camera and it is physically difficult to move between both.

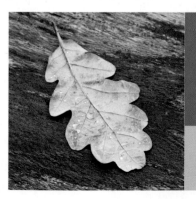

OAK LEAF
The scene, with no bright highlights or deep shadows, was correctly exposed by using center-weighted metering.

Canon 7D, 70–200mm lens (at 200mm), 6 sec. at f/14, ISO 100

Histograms

The LCD on the back of your camera is generally not an accurate way to assess the exposure and tonal range of your photos. A better way is to use a histogram. A histogram is a graph showing the distribution of tones in your photos. The horizontal axis represents the brightness levels in a photo, from black on the extreme left of the histogram through to white at the extreme right. The vertical axis represents the number of pixels of each tone in a photo. Most cameras will allow you to view a histogram of your photos, either in 'live view' before capture, or in playback after the exposure has been taken.

There is no ideal shape for a histogram. However, if it is 'clipped' the tonal range has exceeded the point at which detail could be recorded. When the histogram is clipped on the left, no detail will be recorded in the darkest parts of your photo; those areas will be pure black. When the histogram is clipped on the right, no detail will be recorded in the brightest parts of your photo; those areas will be pure white.

A camera's dynamic range is a measure of

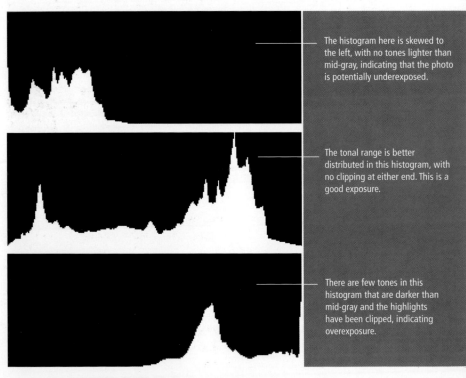

The histogram here is skewed to the left, with no tones lighter than mid-gray, indicating that the photo is potentially underexposed.

The tonal range is better distributed in this histogram, with no clipping at either end. This is a good exposure.

There are few tones in this histogram that are darker than mid-gray and the highlights have been clipped, indicating overexposure.

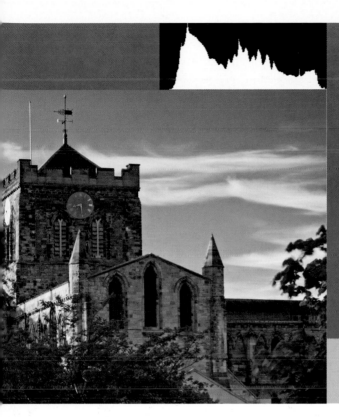

A FINE BALANCE
This photo of Hexham Abbey, Northumberland, United Kingdom, was trickier to expose for than I initially anticipated. With lots of shadow and highly reflective clock faces, I had to consult my camera's histogram carefully to avoid clipping either end.

Canon 7D, 70–200mm lens (at 78mm), 0.4 sec. at f/11, ISO 100

its ability to capture both shadow and highlight detail. A DSLR typically has a greater dynamic range than a compact. If the contrast range of the scene in front of you is greater than the camera can record, clipping will inevitably result. Using filters such as ND graduates is one way to control the contrast *(see page 48)*. Another technique is to use fill-in flash, extra lighting, or reflector boards. If none of these methods is suitable, you will need to decide which part of the tonal range is important and which part you

are prepared to sacrifice detail in. You would then expose your photo accordingly, using exposure compensation if you need to override the exposure suggested by your camera.

A rule of thumb is that loss of shadow detail is less objectionable than losing detail in the highlights. Another method of creating greater dynamic range is to shoot different exposures, one for the shadow detail, a middle exposure, and one for the highlight detail, and merge them into an HDR photo *(see page 88)*.

Contrast

The difference between the highlight and shadow areas of a scene is the contrast. The greater the difference, the greater the contrast.

A photo that is pure black and white with no gray tones is the highest contrast possible. Conversely, a photo in which the darkest tones are similar in density to the lightest tones would be a low-contrast image. Like many aspects of photography, there is no right or wrong answer to the amount of contrast a photo needs.

In many ways, contrast is more important to the success of a black & white photo than a color one. Because a black & white photo is all about tones, how you control the tonal range will determine its impact and emotional resonance. As an example, it is easier to convey a sense of romance or atmosphere in a photo by using low contrast rather than high.

Different types of lighting create different levels of contrast. Point light sources create strong contrast. The sun is a point light source, as is a flashgun. These are very direct sources of light emanating from a small source. Diffusing a point light source helps to reduce contrast. This happens naturally to sunlight on an overcast day. Because the sun's light is scattered by cloud, it appears to emanate from a larger area of the sky. This reduces the brightness of highlights and the density of shadows. The same effect can be achieved when using a flashgun by bouncing the light from a reflector onto your subject or by using a softbox attached to the flashgun.

HAZY BORROWDALE
Dust or water in the air creates haze that reduces contrast considerably. This is a view from the summit of Cat Bells in the English Lake District. The day was bright, but the light was extremely flat. This is one of the unprocessed RAW files from a series I shot that day.

Canon 5D, 100mm lens, 1/200 sec. at f/11, ISO 100

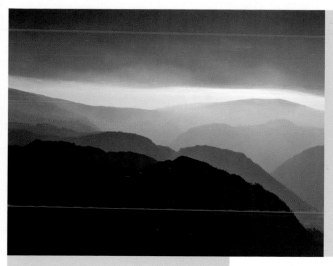

APPLYING CONTRAST

Because the contrast was so low, I used the Curves tool to expand the tonal range to include darker tones as well as light. This increased the overall contrast.

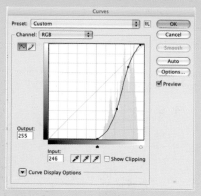

If you intend to edit your photo in Photoshop, it is always easier to start with a 'flat' photo and add contrast than to try to remove contrast. Using a spot meter *(see page 45)*, it is easy to determine the contrast range of your scene and whether any action is required to bring the contrast level down to a manageable level.

Contrast can be controlled by the use of additional lighting or by using reflectors on the opposite side of your subject to the main light source. If you are shooting JPEG, set the contrast applied to the photo to its lowest setting. This is usually done on the 'shooting' menu as one of the 'creative style' choices. Contrast is altered in Photoshop using tools such as Curves, Levels, and Brightness/Contrast *(see page 44)*.

High- and low-key exposure

The distribution of tones plays an important part in the creation of the mood of your photo. Brooding or ethereal moods can be achieved by low- and high-key exposure respectively.

Low key

Low-key photos can be foreboding, mysterious, sinister. They tend not to be optimistic or jolly. A low-key photo is dominated by dark tone. Any light tones present are usually only there to define the shape of your subject. When creating portraits, this may involve the use of only one light to illuminate the edge of the face. Low-key landscapes are mostly shot in stormy weather or at the ends of the day when the light levels are naturally low.

A low-key photo will usually have a histogram skewed to the left. This would normally indicate an underexposed photo, but in this instance that is precisely the effect we are after. However, if possible, expose so that detail is retained in the shadow areas without losing highlight detail. It is easier to reduce brightness in Photoshop later than to recover shadow detail that is no longer there.

High key

A high-key photo is airy, innocent, romantic. It is not pessimistic or brooding. There are usually few dark tones in a high-key photo. High-key photos need to be lit well so that the highlights are similar tonally to the shadows.

A photo that is high key will usually have a histogram skewed to the right. When exposing, be careful not to lose the highlight detail. If your shadow areas are too dark, you may need to light them to lower contrast. This can be achieved through the use of reflector boards or flash.

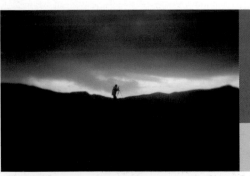

LOW KEY
I used my spot meter and measured from the strip of light across the horizon. Once I had the right exposure setting for that region of the photo, I knew from the contrast level that everything else would be darker than mid-gray.

Pentax 67II, scanned film, exposure details unrecorded

Epson 4990 flatbed scanner, scanned at 1200ppi

HIGH KEY
These petals were scanned on a flatbed scanner. Because the light was relatively even, there were no hard shadows.

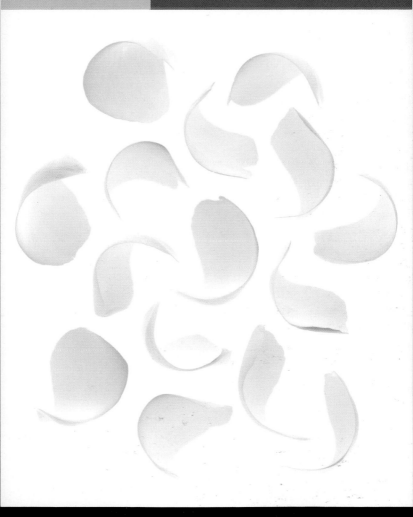

Silhouettes

Creating a silhouette requires extreme levels of contrast. Silhouettes are primarily about the shape of your subject rather than texture.

To make an interesting silhouette, you need to pick your subject carefully. Choose a subject that has a bold, recognizable shape that isn't too three-dimensional. If possible, ensure that the area around your subject is open with no distracting elements entering into the picture frame. If you are creating a silhouette of a person, a profile view will be far more effective that a view from the front.

The light behind your subject has to be much stronger than any light falling onto it. Outdoors, silhouettes are easier to create at the ends of the day when the sky is still bright but ambient light levels are low. In a studio, you should light your subject from behind and with little or no light at the front.

Because your subject is dark (and you want it to remain that way!) your camera meter may overexpose to compensate. If your camera has a spot meter mode, switch to that and meter from the background. If your camera lacks that facility, you may need to use exposure compensation. The level of compensation will vary from scene to scene but two or three stops underexposure is a good starting point.

In automatic modes, many cameras will opt to use flash in this sort of lighting situation. Make sure that flash is switched off before you begin.

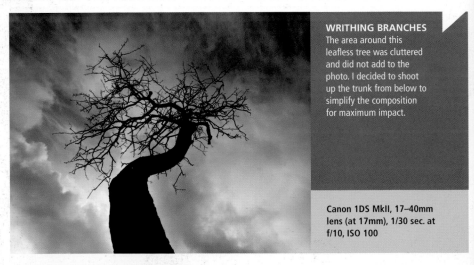

WRITHING BRANCHES
The area around this leafless tree was cluttered and did not add to the photo. I decided to shoot up the trunk from below to simplify the composition for maximum impact.

Canon 1DS MkII, 17–40mm lens (at 17mm), 1/30 sec. at f/10, ISO 100

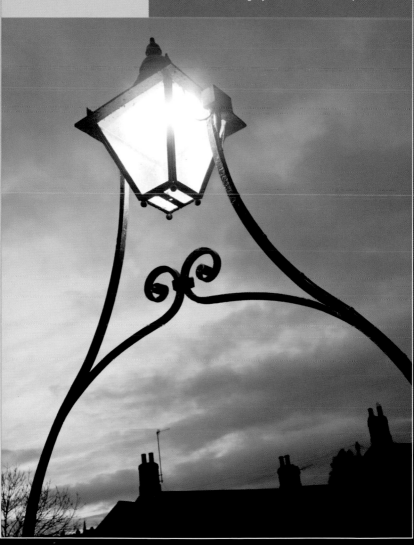

Canon 1DS MkII, 17–40mm lens (at 17mm), 1/30 sec. at f/10, ISO 100

STREETLIGHT
I liked the way this ornate streetlight framed the houses behind. Because there are no depth cues, it is hard to judge relative sizes, an ambiguity that works well in this photo.

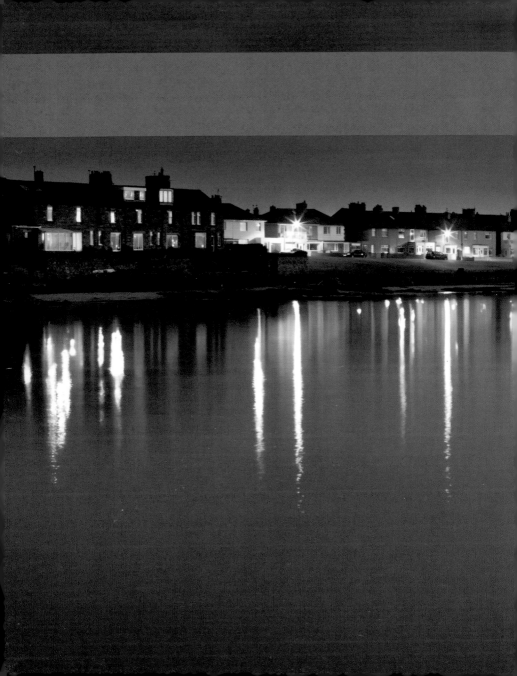

CHAPTER 4 COMPOSITION

Composition

Each photo you make is a story of a particular time and place. Composition is the arrangement of the various elements in your photo that help tell the story in the most pleasing manner.

There are a few rules that can be followed that help to create pleasing composition. However, following these rules can lead to formulaic pictures. It is often worth knowing about the rules just to be able to break them! A few of the more common rules are given here. The rest of the chapter discusses some of the other compositional rules to experiment with.

BALANCE
The crag on the right of this photo helps to 'balance' the tree on the far left.

Pentax 67II, scanned film, exposure details unrecorded

Rule of thirds

Imagine your photo divided into nine equal segments by two horizontal and two vertical lines. The rule of thirds states that your subject should not be placed in the center of the photo, but at the intersection of two of these lines.

Symmetry

If your photo could be folded in two and the two halves match, you would have a symmetrical composition. These can be very pleasing, but adding in an element that breaks the symmetry will add dynamic tension to your photo.

Balance

If your photo were on a pivot, by adding your subject off-center the photo would become unbalanced. Consider how you can add something of less importance on the other side to help restore the balance.

Leading lines

As viewers, we like to follow lines through photos. A leading line is an element in a photo that draws our eye toward the main subject. Leading lines can be made from many things such as natural shapes in the landscape and architectural features.

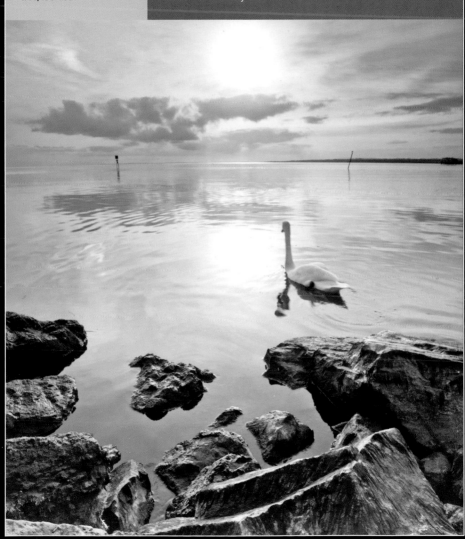

Canon 1DS MkII, 17–40mm lens (at 19mm), 1/15 sec. at f/11, ISO 100

LEADING LINES
I placed this swan on a right third to make it look as though it were swimming into the center. If it were placed on the left third, the photo would look decidedly odd.

Photo shape

The initial size and proportion of your digital photograph is determined by your camera. However, you should not feel constrained by this. Cropping a photo to improve it is part of the creative process.

There are many reasons to crop a photo. Sometimes you may not be able to get as close to your chosen subject as you'd like. Cropping will help to remove any extraneous detail and help to simplify your photo *(see page 68)*. Another good reason is that your composition may work more effectively in a different shaped photo.

The traditional '35mm' shape used by most DSLRs is a rectangle with the proportions of 3:2 (the longest edge is 1.5 times greater than the shortest). Compacts and cameras developed following the Four Thirds standard produce images in the proportions of 4:3 (the

longest edge is only 1.33 times greater than the shortest, which matches the proportions of a standard television).

However, there is no reason not to compose for a square or for a long panoramic. If your camera has the facility to overlay grid lines in the viewfinder or LCD, this will help you decide the shape of your photograph. Use the lines as a basis for where you will ultimately crop your photo. If your camera does not have a grid lines facility, mentally divide the viewfinder into sections and keep the most important elements of your photo within these boundaries.

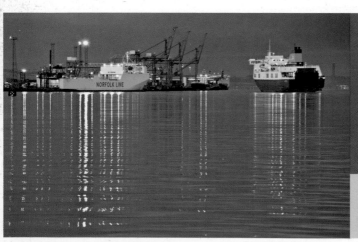

DOCKING
It's sometimes possible to find a number of different, equally valid, photos within one. This photo of a ferry docking is the original. On the opposite page are a few examples of further compositions I created by selective cropping. Which do you prefer?

Canon 1DS MkII, 70–200mm lens (at 200mm), 0.4 sec. at f/8, ISO 250

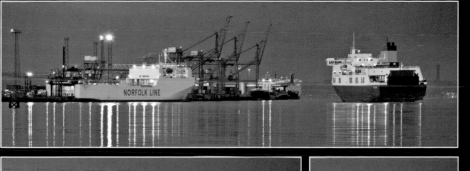

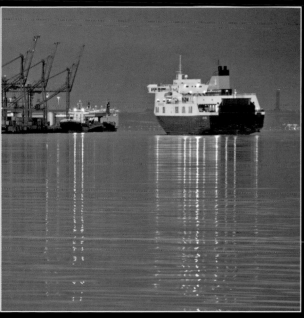

Abstraction

One of the joys of photography is creating a photo that is not instantly recognizable. This will make it more difficult to interpret, but will impart a sense of mystery that will invite a lingering look.

An abstract composition is one that has no immediately apparent subject. This is usually achieved by removing as many visual clues about the subject, such as overall shape or size, as possible.

The 'closer' you are to your subject, the more abstract will the image become. Long focal-length lenses are ideal for creating abstract photos. They allow you to crop in more and isolate your subject in a way that will be more difficult with a wider-angle lens. Macro lenses are also useful for similar reasons.

Abstract photo opportunities can be found anywhere and everywhere. Look around your home. Even the most mundane objects can be shot in an abstract way. Look for interesting texture or patterns within your subject. Using the selective focus technique *(see page 70)* will increase the sense of mystery found in a good abstract photo.

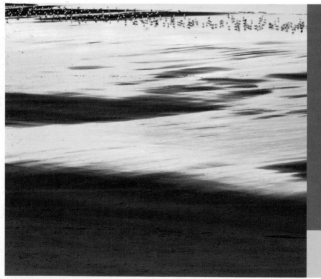

BEACH
For this photo I used a long lens to crop tightly on the patterns caused by the wet and dry sand.

Canon 1DS MkII, 200mm lens, 1/40 sec. at f/11, ISO 100

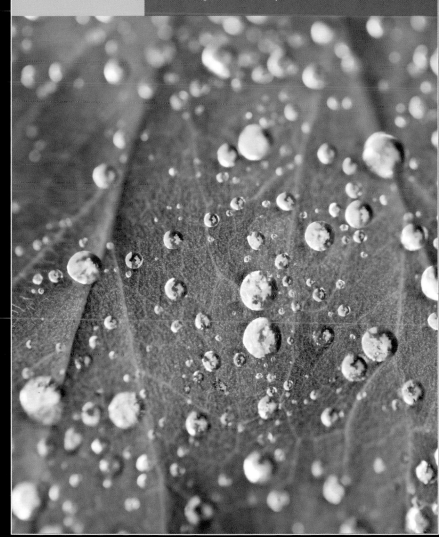

Canon 1DS MkII, 100mm
lens, 1/125 sec. at f/4.0,
ISO 400

DROPLETS
By using a macro lens I was able to fill the frame with these
water droplets on a leaf. It is almost impossible to get a sense
of scale, though the leaf was only a few inches across.

Repetition

Once you start to look, repetitive patterns can be found everywhere, both in the natural world and in the built environment. Repetition is pleasing to the eye; it's not dynamic but soothing.

To convey repetition successfully, you should suggest that the pattern could continue forever outside the boundary of the photo. This will require you to fill the frame with the pattern so that there are no gaps that break the sequence. Again, the use of a longer focal length lens is ideal for this sort of photography.

For a more dynamic approach, look for elements that break the pattern. This will add an immediate focal point for your composition. Think about the placement of this element within the frame. If possible, place it where it will have maximum visual impact. Too near the edge of the frame and the placement could look half-hearted.

Shooting a flat pattern, in a flat plane parallel to your camera, will not require a great depth of field. However, if your pattern is three-dimensional think carefully about where to place your focus point to maximize sharpness. Remember, depth of field extends less far in front of the focus point than it does behind.

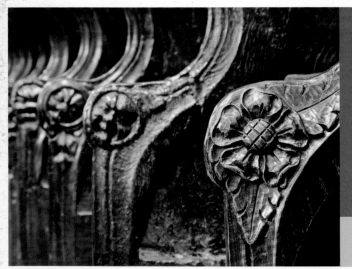

SEATING
I found these carved armrests in a local church fascinating. I didn't include the entire row, but concentrated on just the first four. I was confident that this would be enough to convey the idea of the pattern continuing.

Canon G10, lens at 30.5mm, 13 sec. at f/4.5, ISO 80

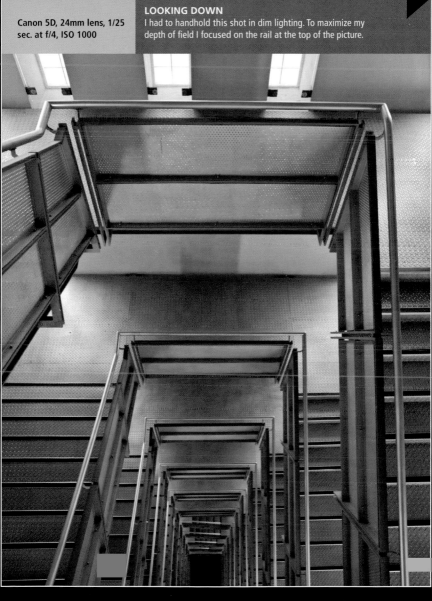

LOOKING DOWN
I had to handhold this shot in dim lighting. To maximize my depth of field I focused on the rail at the top of the picture.

Canon 5D, 24mm lens, 1/25 sec. at f/4, ISO 1000

Using frames

Framing will help to focus attention on your photographic subject. Used well, it will also add depth and interest to your composition.

Depth of field will be an important consideration when you frame your composition. If the framing element is some distance from your main subject, but close to your camera, it may be difficult to get both sharp. However, this is not necessarily a bad thing. Be bold, use a large aperture so that your framing element is very out-of-focus and set your focus point on the subject. The out-of-focus areas will help to give your photo depth.

Frames that are darker than your subject also help to draw attention to it. Silhouettes (see page 52) make particularly good framing devices. If shooting a silhouette, look for bold shapes that don't detract from the main subject. Anything too ornate would be worthy of a photo in its own right!

Think about how the framing device relates to the subject. Is there a link? If so, how do you make that obvious? Framing devices don't have to have any relation to the subject, but those that do will give your subject more context.

Framing can also help to convey different emotions. A visually dominant frame around a subject could be oppressive or it could be reassuring. An out-of-focus frame could be made to feel voyeuristic or intimate. If a photo is a story, framing can help you tell it.

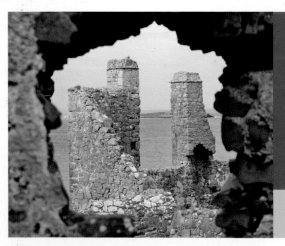

GLIMPSED RUINS
I deliberately focused on the tower in the background and left the surrounding wall out-of-focus to mimic the way that I originally saw the scene.

Canon 1DS MkII, 70–200mm lens (at 70mm), 1/320 sec. at f/5.0, ISO 100

Canon 5D, 50mm lens, 1/160 sec. at f/6.3, ISO 400

I liked the shyness of this young girl, conveyed by the way she is framed by the door to her house.

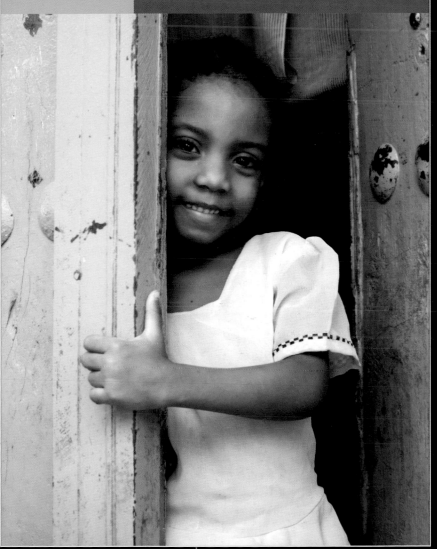

The decisive moment

All photographs are moments in time captured for posterity. The 'decisive moment' is the precise instant that all the elements of your photo come together to make a coherent and interesting composition.

Anticipation is the key to knowing when the decisive moment is about to occur. This involves a certain amount of watching and waiting. The more you know about your subject the better. If you are taking photos of a sporting event, it helps to know the rules and the likely outcome of a particular move by the players. In unfamiliar situations involving people, try to work out the different personality types involved. Bolder people are more likely to be demonstrative than reserved people. Look out for extravagant hand gestures and unusual behavior.

Successfully capturing the decisive moment also means knowing your camera well. If you need to think about creating a photograph, it probably means the moment will pass before you're ready. If possible, use a prime lens and get to know its characteristics. With practice, it soon becomes second nature to frame a composition without conscious thought. Using a zoom lens can actually be counterproductive, again because working your way through the zoom range and deciding on a particular focal length takes time.

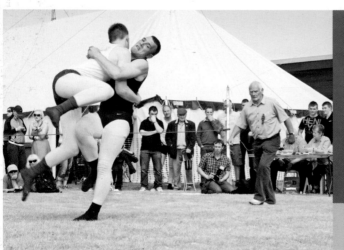

FALLING
I didn't know anything about the sport of Cumberland Wrestling when I went to photograph a competition. After ten minutes of watching, I was able to anticipate what would occur and be ready for the key moments.

Canon 7D, 50mm lens, 1/250 sec. at f/7.1, ISO 100

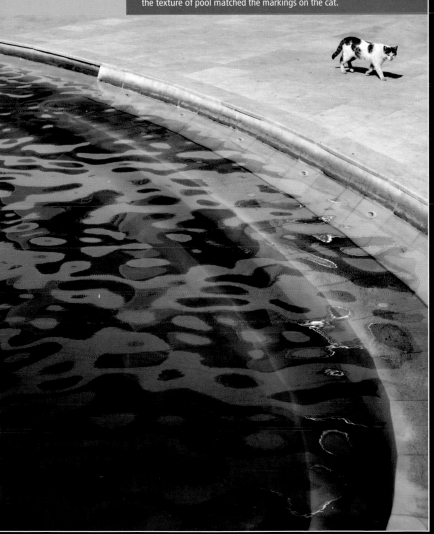

POOLSIDE CAT

Luck occasionally plays its part when creating a photo. Relaxing by a pool, I saw this cat warily walking around the water's edge. I shot one frame out of curiosity. It was only when I got home that I realized that the texture of pool matched the markings on the cat.

Canon 5D, 50mm lens, 1/1000 sec. at f/7.1, ISO 200

Keeping it simple

What you leave out of a photo is as important as what you leave in. Adopting a minimalist approach to composition will take that concept to its ultimate conclusion.

Some photos can be so full of detail that it is difficult to know where to look. A simple composition is often more powerful than a cluttered one because it will have one message to convey rather than many.

Rather perversely, simplicity is often difficult to achieve. The world is a visually complex and chaotic place. The first step toward simplifying a composition is to decide what is and isn't important to the photo. Move around your subject, looking for the least cluttered background. You should give some thought to which lens you want to employ during this process: remember that a wide-angle lens will include a lot more of the background than a longer lens.

Once you have the basic composition worked out, set up your camera and take a look around the edges of the viewfinder. Is there anything intruding into the picture space that should not be there? When you are satisfied that the composition cannot be improved, consider the aperture and shutter speed. Long shutter speeds (see page 40) are particularly useful for minimizing distracting elements that may move during exposure. Selective focus (see page 70) is another useful technique that can help simplify a composition.

STORM FRONT
The subject in this photo is the light breaking through the clouds as a rain shower passes overhead. I included just enough of the surrounding moorland to give a sense of place, without detracting from the effects of the elements.

Canon 1DS MkII, 70–200mm lens (at 85mm), 1/500 sec. at f/8, ISO 200

BREAKING THROUGH
Snow simplifies the landscape. These branches would have been lost against a background of similar tones without the snow to add contrast.

Selective focus

When looking at a photo, we tend to avoid lingering over out-of-focus areas. We can use this quirk of visual perception to deliberately direct the eye to a precisely chosen part of a photo.

The selective focus technique uses a large aperture for minimal depth of field *(see page 38)* and requires you to focus precisely on a selected part of the scene. This will be the focal point of your photo, so you should choose carefully where this is. The closer the focus point is to the lens, the smaller the depth of field and the more pronounced the effect. Autofocus systems sometimes struggle with close-up subjects, often 'hunting' or shifting in and out of focus without settling. If this happens, switch your lens to manual and focus using the lens focus ring.

Once you've chosen your focus point, set the widest aperture you can on your camera—you may need to use manual or aperture priority, since automatic exposure modes won't necessarily select this for you. Take the photo and review the result on the camera's LCD screen. Zoom in as far as possible and check the point of sharp focus in the photo. If the focus is slightly out, adjust the lens and take the photo again. Because you are using the lens wide open, you should have a reasonably fast shutter speed, allowing you to handhold the camera. However, using a tripod will allow you to repeat the process more consistently.

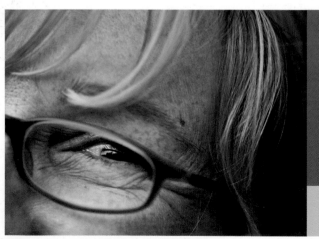

LOOKING
In this photo, I focused precisely on my subject's eye. Even though her spectacles are only a fraction of an inch farther forward, the depth of field was so small that they are out of focus.

Canon 1DS MkII, 100mm lens, 1/400 sec. at f/3.2, ISO 320

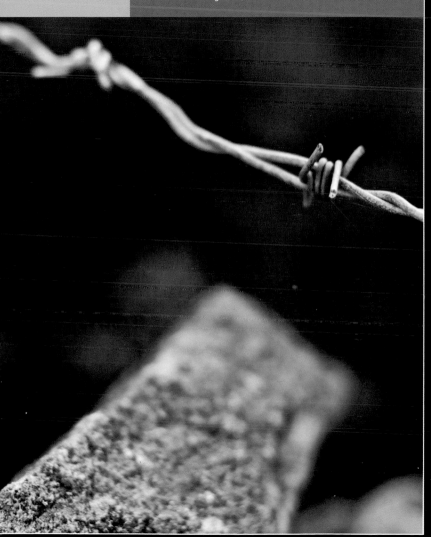

**Canon 7D, 50mm lens,
1/160 sec. at f/2.2, ISO 100**

As the knot of barbed wire wasn't near an AF focus point, I had to switch to manual focus. Set to autofocus, the camera focused on the background, which ruined the effect.

A splash of color

Retaining a small amount of color in your black & white photo is an effective way to draw the viewer's eye to a particular area of the composition. *See page 120* for more about the technique.

Canon 7D, 70–200mm lens (at 90mm), 1/80 sec. at f/8, ISO 100

Digital Black & White Photography

Framing

I liked the contrast between the soft leaves in the foreground and the hard shape of the bridge behind that they neatly framed. I used a long shutter speed so that the leaves blowing in the wind were recorded as an expressionistic blur, further emphasizing their softness.

Canon 7D, 50mm lens, 18 sec. at f/18, ISO 100

Getting in close

By using a macro lens, I was able to get in very close to my cat to create a photo. This helped to simplify the composition considerably. Now the photo is very much about the cat's nose and the texture of the skin.

Pentax 67II, scanned film, exposure details unrecorded

Tidal water

The 'decisive moment' applies equally to landscape as it does to human events. I had to wait for the moment when the tide was sufficiently high that the sea washed around the stone in the foreground. When it finally did, because I was set up, it was just a case of pressing the shutter-release button.

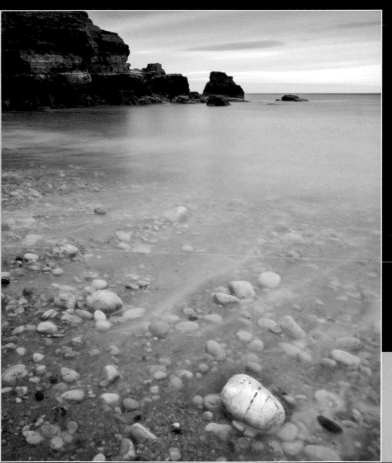

Canon
1DS MkII,
17–40mm lens
(at 27mm), 30
sec. at f/18,
ISO 100

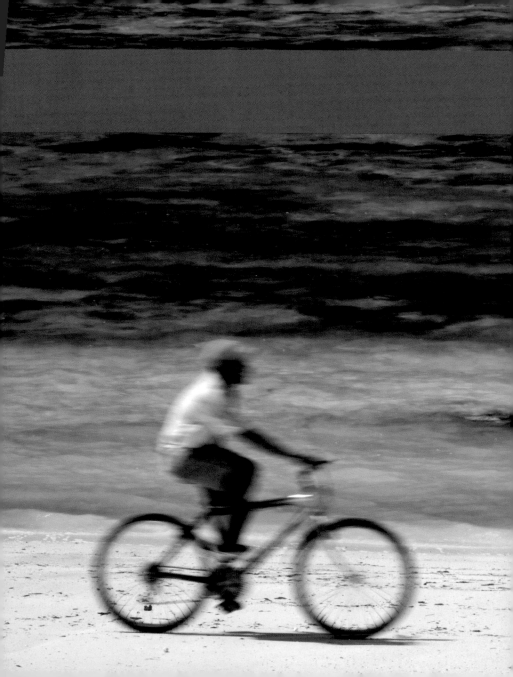

CHAPTER 5 COLOR TO BLACK & WHITE

Photoshop

The first version of Adobe Photoshop was released in 1990. Since then it has become such a familiar photo editor that the name has become a verb. To 'Photoshop' is widely recognized as altering a photo.

Adobe Photoshop is a big, complex package aimed at a variety of users, from graphic artists to movie effects specialists to, of course, photographers. As a result, it can be a daunting piece of software to learn. This book assumes some knowledge of Photoshop, such as importing and saving files, and basic editing. The tools that will be used most often in the following chapters are described in the next few pages. The more arcane and obscure functions

of Photoshop will not be described, since their use is outside the scope of this book.

The current version of Photoshop (CS5) is the twelfth version released since 1990. Each new version increases the number of features. To make this book as accessible as possible, only functions available in Photoshop CS2 onward (released 2005) will be used. Users of the latest versions of Adobe Photoshop Elements should also be able to follow the examples described.

PHOTOSHOP CS3
Making a levels adjustment using Photoshop.

Converting to Black & White: desaturation

By far the simplest and quickest way to convert a photo to black & white is to select **Image/ Adjustments/Desaturate**. However, the results can often look flat, since there is no control over how the different colors in the photo will be converted to monochrome tones. The same effect can be achieved with **Image/ Adjustments/Hue/Saturation** and dragging

the Saturation slider down to -100. Although this is not the best way to create black & white images, we'll be using the Hue/Saturation adjustment tool to tint our photos in the following chapter.

1) Select **Hue/Saturation** and check Colorize.

2) Use the Hue slider to globally tint your photo. As your move the Hue slider, the tint of your photo cycles through the full spectrum of colors. The Saturation slider can be used to adjust the vibrancy of the selected color.

3) Finally, you can use the Lightness slider to lighten your photo through to pure white, or darken it down to pure black.

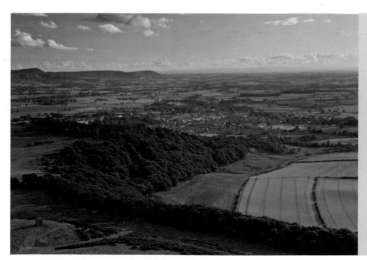

FLAT TONES
You have no control over how the tones are converted to black & white when using Desaturate. For this reason the results can look very flat.

Channel Mixer

Each pixel in your photo is made up of a combination of red, green, and blue. Channel Mixer allows you to blend different proportions of these colors to create the final tones in your black & white photos. For example, by increasing the red percentage value you would lighten the gray tones derived from the red in your photo. Decreasing the percentage would darken the gray tones derived from red.

1) Open **Image/Adjustments/Channel Mixer**. Check Monochrome at the bottom of the dialog box. Your photo should now be converted to black & white. However, note that this is just the default conversion.

2) Use the Source Channel sliders to adjust the percentage of the mix of red, green, and blue. The total percentage is shown below the sliders. A total greater than 100% will cause clipping in the highlight details of your photo. Less than 100% will cause clipping in the shadows. If you make an adjustment to one slider, you will have to make an opposite adjustment to one or both of the other two to maintain the correct tonal range.

3) The Preset drop-down menu has a range of default settings that mimic the effects of using different color filters *(see page 31)*. Selecting one of these presets will set the sliders automatically to the relevant red, green, and blue mix.

4) Moving the Constant slider to the right will lighten your photo. Moving the slider to the right will darken it.

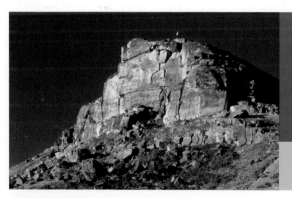

ROSEBERRY TOPPING
I used the Black & White with Red Filter preset to convert this photo from color to black & white. The blue sky has darkened considerably compared to the color original, but the red rock is much lighter.

Canon 7D, 70–200mm lens (at 138mm), 1/15 sec. at f/11, ISO 100

Black & White

The Black & White adjustment tool offers the most sophisticated Photoshop conversion method. As with Channel Mixer, you control how colors are converted into tones. However, the range of colors you can adjust far outstrips the three in Channel Mixer.

1) Open **Image/Adjustments/Black & White**. The photo will be converted to black & white. Click on Auto to create an automatic color mix based on the colors in your photo.

2) Adjust the mix of colors by moving the sliders. The greater the percentage of a color, the lighter the gray tone conversion of that color. The smaller the percentage, the darker the gray tone. Selecting Preview allows you to see the photograph before and after conversion.

3) The Preset drop-down menu has a range of default settings that mimic the effects of using different color filters *(see page 31)* and infrared *(see*

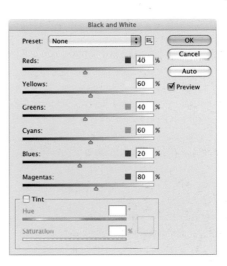

page 126). Selecting one of these presets will set the sliders automatically to the relevant color mix.

4) If you want to save a particular color mix for future use, click on the preset icon to the right of the drop-down menu. Select Save and give your custom preset a relevant file name. By default, custom presets are saved in the Photoshop Black & White preset folder. Once saved, the custom preset can be found in the Preset drop-down menu.

5) Selecting Tint at the bottom of the dialog box lets you tint your image a particular overall color in a similar manner to Colorize in Hue/Saturation.

CAPTAIN COOK
Using the Tint option, it is very easy to apply a subtle overall color to your black & white conversions.

Canon 7D, 70–200mm lens (at 200mm), 1/200 sec. at f/4, ISO 100

Tonal Adjustments

There are many reasons why an image straight from a digital camera (or scan from a slide or negative) may be unsatisfactory. The exposure meters in modern cameras are astonishingly sophisticated, but they are not foolproof, and sometimes the exposure will be incorrect so that the image is too dark (underexposed) or too light (overexposed). If you are shooting RAW, you may also find your photo needs other adjustments—such as contrast—to the tonal range.

Brightness/Contrast

The simplest tonal adjustment you can make to your photos is to increase or decrease the contrast. The easiest way you can achieve this in Photoshop is to use the Brightness/Contrast tool.

1) Open a photo, then select **Image/Adjustments/Brightness/Contrast**. Leave Use Legacy unchecked.

2) Use the Brightness slider to lighten or darken the photo. Moving the slider to the right expands the highlight range. Moving the slider to the left expands the shadow range.

3) Use the Contrast slider to compress or expand the photo's tonal range. Moving the slider to the right

increases contrast, narrowing the range of tones. Moving the slider to the left decreases contrast, adding to the range of tones present in the photo.

4) Checking Use Legacy offers a more extreme range of brightness and contrast adjustment, with a greater likelihood that highlight and shadow detail will be lost.

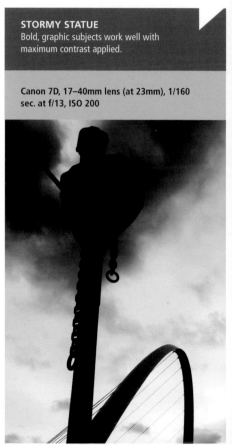

STORMY STATUE
Bold, graphic subjects work well with maximum contrast applied.

Canon 7D, 17–40mm lens (at 23mm), 1/160 sec. at f/13, ISO 200

Levels

A more sophisticated way to adjust the tonal range of your photo is to use the Levels tool. The Levels tool allows you to adjust the strength of the shadow, mid-tones, and highlights with great precision.

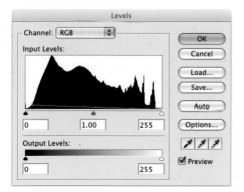

1) Open **Image/Adjustments/Levels**. At the center of the dialog box is a histogram showing the tonal range in your photo.

2) Below the histogram are three small triangles. The solid black triangle is the black point in your photo; this is where the red, green, and blue values of a pixel are all set to 0. The white triangle is the white point, where red, green, and blue are all set to 255. The gray triangle is the mid-tone point in your photo.

3) Moving the triangles redistributes the tones in your photo. For example, by moving the black triangle to the right, more pixels in your photo will be set to black. Conversely, move the white triangle left and more pixels are set to white. Moving the gray triangle

adjusts the brightness level of your photo; move right and the photo darkens, left and it lightens.

4) The black, mid tone, and white points can be set manually by clicking on the relevant color picker below the Options button. For example, select the black color picker. Now, clicking anywhere in your photo will set the pixel color value you clicked on to be the new black point. Anything darker than that pixel value will also be set to black.

5) Output Levels changes the RGB value of the darkest and lightest tones in your photo. Move the black output level right and the darkest tone lightens, move the white output level left and the lightest tone darkens.

6) A particular adjustment can be saved and loaded again for use on other photos by clicking on Save and Load respectively.

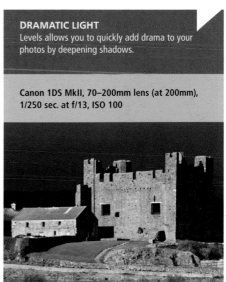

DRAMATIC LIGHT
Levels allows you to quickly add drama to your photos by deepening shadows.

Canon 1DS MkII, 70–200mm lens (at 200mm), 1/250 sec. at f/13, ISO 100

Curves

Curves is the most flexible of the tonal adjustment tools in Photoshop, and possibly the most daunting. In later versions of Photoshop, when using Curves, a histogram is displayed showing the tonal range of your photo. Running diagonally across the histogram is a line from top right to bottom left. Up to 14 points can be placed on this line. By moving the points around the histogram, you change the shape of the line into an increasingly complex curve. In doing so, you will adjust the tonal values in your photo.

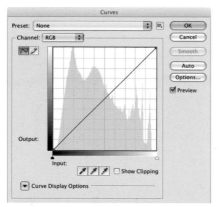

1) The Input line at the bottom of the histogram is a range of tones from black on the left to white on the right. These represent the tones in your photo. Like Levels, moving either of the triangles below the Input histogram, moves the black or white point up or down the tonal range in your photo. When you move the triangles, the end points of the curve above move in the same direction.

2) Click anywhere along the diagonal line to draw a point there. Now imagine a straight line left from that point across to the range of tones in the Output column. The point you've just placed is the tone in your photo that matches the corresponding tone in the Output column. Move the point upwards to lighten that tone in your photo. Move the point downwards to darken it. Add more points to selectively adjust specific areas of tone in your photo.

3) Like levels, the black, mid-tone, and white points can be set manually by clicking on the relevant color picker below the Input line.

4) You can draw your own curve freehand by clicking on the Pencil icon below the Channel drop-down menu.

5) A particular adjustment can be saved and loaded again for use on other photos by clicking on Save and Load respectively.

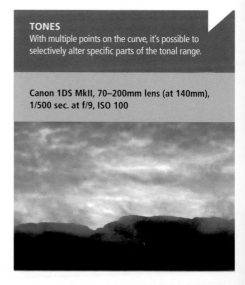

TONES
With multiple points on the curve, it's possible to selectively alter specific parts of the tonal range.

Canon 1DS MkII, 70–200mm lens (at 140mm), 1/500 sec. at f/9, ISO 100

Dodge & Burn

Photoshop was created long before digital photography became mainstream. As a result, there are two tonal adjustment options that hark back to working in a darkroom. The dodge and burn tools are based on the technique of holding back light to lighten specific areas of a print (dodging) and increasing the exposure to darken specific areas of a print (burning).

Both tools are used like a brush to adjust the tones of your photos. The tools are both found on the Tools palette (*below*). Once you've selected either dodge or burn, set the size (in pixels) and hardness by using the drop-down menu on the option bar. Size can also be adjusted by pressing [on your keyboard to shrink the tool and] to expand it.

The tones that the tools affect are set in the Range drop-down menu. Select Shadows and the tool will be biased toward affecting the darker tones in your photo, Midtones biased toward the middle tones, and Highlights toward the brightest tones.

Exposure alters how quickly the dodge and burn tools affect the tones you are altering. A higher value builds up the alteration more quickly than a lower value.

Both the dodge and burn tools can also be used as airbrushes. This will give you a softer effect than the standard brush.

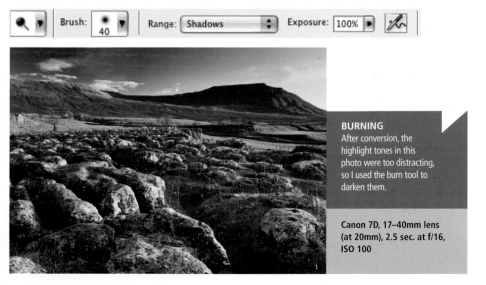

BURNING
After conversion, the highlight tones in this photo were too distracting, so I used the burn tool to darken them.

Canon 7D, 17–40mm lens (at 20mm), 2.5 sec. at f/16, ISO 100

Layers

Once you've made an adjustment to your photo in Photoshop (unless you undo the adjustment immediately), it is almost impossible to recover what was there previously. This is particularly true once the photo has been saved.

Adobe solved this fundamental problem with the concept of 'layers.' A layer is analogous to a sheet of glass laid over your photo. Making any adjustment to a layer will not permanently alter any of the pixels of the photo underneath.

Stacking layers

You can add numerous layers to a photo and they can be seen stacked in the Layers palette. The highest layer in the stack is above all the others, the lowest (which will be your original photo and called the Background by default) is at the bottom of the stack. Layer order can be changed by dragging layers up or down the stack.

Transparency and opacity

The transparency or opacity of a layer can be adjusted by altering the Opacity value. At 100% the layer is fully visible, at 0% it is completely transparent. How the layer interacts with those below it can be changed using the Blend mode drop-down menu. The Blend mode determines how pixels interact and are mixed between the various layers.

Layers can be turned on or off by clicking on the eye icon on the left side of the Layers palette. To permanently remove a layer, drag it down to the trash can on the bottom right of the palette.

Compatible file formats

Not all file formats support layers, but Photoshop's .PSD format and TIFF are compatible. JPEG is not compatible with layers and the layers must be flattened (or merged into the background layer) before you save in this format.

If the Layers palette is not displayed, select **Windows/Layers.**

Adjustment layers

The black & white and tonal adjustments we've covered so far (with the exception of dodge and burn) can also be applied as Adjustment Layers. An adjustment layer does not contain any pixel information. It is a recipe that makes changes non-destructively.

The same dialog boxes will be displayed for the relevant tools when you add them as adjustment layers. To add an adjustment layer to your photo, click on the adjustment layer icon from the bottom of the Layers palette. Select the relevant adjustment and follow the instructions for the tool noted previously.

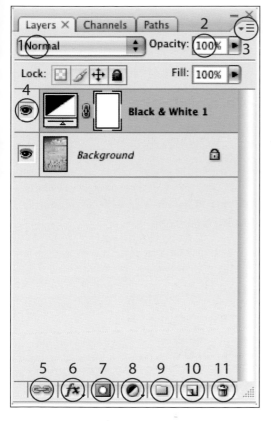

Layers palette

1 Blend mode drop-down menu. The default is normal.

2 Opacity. Reducing the opacity will reduce the effect the layer will have on the other layers below.

3 Layer options menu. Includes the options for flattening the layers.

4 View layer. Clicking on the eye will turn the layer off. Clicking again will turn the layer back on.

5 Link layers. Layers can be linked together for moving or to be merged as a group without flattening the entire image.

6 Layers effects. Adds an effect to a layer such as applying an embossed look.

7 Apply a mask to the current layer.

8 Add an adjustment layer.

9 Add a layer group. Layers can be collected together as a group. This helps to stop the layers palette looking too cluttered. A group can be switched off temporarily; this will also switch off all the layers within that group.

10 New layer. Dragging an already existing layer to the new layer option will make a copy of that layer.

11 Delete layer.

High Dynamic Range (HDR)

Digital sensors cannot cope with the same level of contrast as the human eye. One way to overcome this limitation is to merge a combination of photos exposed for different parts of the contrast range.

HDR really comes into its own in situations where there are bright highlights and deep shadows and you want to retain detail in both. Some cameras have recently been released that can create HDR photos at the time of exposure. However, the most common method is to use software such as Photoshop.

One drawback with using the HDR technique is that each exposure should have the same content as all the others. Anything that moves between exposures will create odd visual effects when the photos are merged. If you are planning to create a series of images for HDR merging, it is important to keep the camera still

between each exposure, so the use of a tripod is highly recommended.

For effective results, you will need three or more photos of the same subject shot using exposures of at least one stop difference. These may be in JPEG format, though ideally you should start with RAW or TIFF files in 16-bit mode *(see page 16)*.

The more photos you use and the greater the difference in exposure from the darkest to the lightest, the larger the dynamic range of your HDR photo will be. However, more photos means Photoshop will require more time to process the HDR merge.

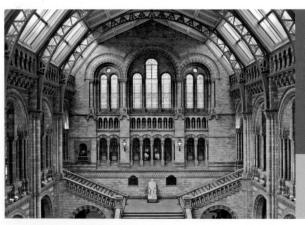

NATURAL HISTORY MUSEUM
This was an ideal candidate for an HDR merge. The contrast range was higher than the camera could cope with. I could either retain detail in the windows or the interior, but not both. The solution was to shoot three exposures with a difference of 4 stops in total.

Canon G10, lens at 8.9mm, various shutter speeds (1/15, 1/60, 1/250), f/3.2, ISO 80

Creating an HDR photo in Photoshop

1) Select **File/Automate/Merge to HDR**. If you have your photos already open in Photoshop, click on the Add Open Files button. Otherwise, choose browse and add your photos using the file browser. Click OK to continue.

2) If the message "There is not enough dynamic range in these photos to construct a useful HDR image" is displayed, you will need to choose photos with a greater difference in exposure. Start back at step 1.

3) A new dialog box will be displayed once Photoshop has assessed your photos. The main image in the middle of this dialog box is a composite of the photos you chose to merge. On the left are thumbnails of the original photos. If you wish to remove any of the photos from the final HDR image, deselect the check below the photo.

4) To the right of the main image is a histogram showing the distribution of tones in the image. Each red line spaced along the histogram is equivalent to one stop of exposure. Use the slider underneath the histogram to move the white point. This will be the starting point for the final exposure.

5) Set the drop-down menu above the histogram to **16 Bit/Channel** and click OK. At the time of writing, Photoshop does not support comprehensive editing in 32 Bit and many of the standard adjustment tools are unavailable.

6) A dialog box will be displayed, with options to convert the HDR image to one that can be easily edited in Photoshop. There are four different options to choose from on the drop-down menu *(see following page)*. Select the appropriate method and click OK.

7) Your photo can now be altered using the standard Photoshop adjustment tools. When you have finished editing and are happy with the changes, select **Image/Mode/8 Bits/Channel** and then save as normal.

HDR MERGE
Dialog box showing the initial HDR photo merge.

Why not try...?

A standalone HDR converter such as Photomatix by www.hdrsoft.com, which is available for both Windows and Mac.

HDR Conversion Options

Exposure and Gamma

Similar to using the Brightness and Contrast adjustment tool in Photoshop. Use the sliders to manually adjust the exposure (brightness) and gamma (contrast) of your HDR photo.

Highlight Compression

Highlight contrast is reduced to create a photo with a tonal range suitable for conversion to 16 Bit or 8 Bit. No user options are available with this method.

Equalize Histogram

The dynamic range of the photo is compressed to create a photo with a tonal range suitable for conversion to 16 Bit or 8 Bit. Again, there are no user options with this method.

Local Adaptation

This is the most complicated, but ultimately the most flexible method of converting an HDR photo. Local adaptation exploits the way human vision works by tricking it into seeing more contrast in the HDR photo than there actually is.

Adjustment sliders

The Radius slider adjusts the size of local brightness regions. The Threshold slider adjusts the sensitivity of the Radius setting. A high threshold increases local contrast, but also increases the likelihood of distracting 'halo' artifacts. A low threshold can make the photo look flat and washed out. Different photos will require different settings of both radius and threshold, and ultimately only experimentation will allow you to judge what those settings are.

A tone curve allows you to make further adjustments to the brightness and contrast of your HDR photo before final conversion.

HDR CONVERSION
Using Local Adaptation has given me greater control over the conversion of this three-exposure HDR photo.

Filters

The default filters available with Photoshop allow you manipulate your images in a variety of weird and wonderful ways. Filters are 'destructive' in that they fundamentally alter the pixels in a Photoshop document. Once a filter has been applied, it is almost impossible to recover what was there previously without immediately undoing the filter. Therefore, filters should be used wisely: if you are unsure whether a filter will achieve the effect you are after, it is worth making a duplicate of the layer you want to alter and experimenting with this new layer. If your changes don't work as intended, delete the layer copy and go back to the original.

Filters are grouped into type sub-menus from the main Filters menu in Photoshop. The main filters we'll be using in this book are found on the Artistic, Blur, Noise, Render, Sharpen, Sketch, and Texture sub-menus. To use a filter, select it from the type sub-menu. The filter dialog box will then be displayed.

Most filters have a variety of parameters that can be altered with a slider to change the strength or range the filter will have. The effect the filter will have will be shown in a window in the dialog box. Once you are happy with any changes you make, click OK and the filter will be applied. The effect the filter has had on your photo can then be further modified by selecting **Edit/Fade.** This will allow you to alter the opacity of the applied filter and change the blend mode.

A number of third-party filters is also available. These filters vary in sophistication, but do add to the overall capability of Photoshop. When installed, they will be displayed at the bottom of the Filter menu.

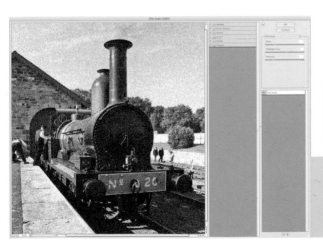

Why not try...?
The AutoFx range of Photoshop filters. www.autofx.com

FILM GRAIN
The Film Grain filter in use.

Alien Skin: Exposure 3

Exposure 3 is a third-party filter for Photoshop that was created by Alien Skin Software *(www. alienskin.com).*

The Alien Skin team have been producing filters for use with Photoshop since 1993. The Exposure filter allows you to recreate the visual style of a wide variety of different film types, both color and black & white. The philosophy of the filter is to 'take the digital out of digital photography.' Exposure 3 is also compatible with Lightroom 2 and later.

Exposure has a greater number of options than a typical Photoshop filter. This initially makes the dialog box appear quite daunting, but it doesn't take long to become familiar with the how the filter works.

Settings

Clicking on the Settings button displays the full range of film types that Exposure emulates. Different film types have varying contrast, grain, sharpness, and color sensitivity. Selecting a particular film type replicates these characteristics. There are also options to apply vignettes to a photo, soften, and to emulate the lo-fi look of 'toy cameras'—cheap film cameras with plastic lenses.

Color

Using the film presets is a good way to understand how Exposure works. However, these presets can be refined further. The Color button enables you to choose how the photo is converted to black & white by altering the red, green, and blue sliders. This is similar to the way the Black & White adjustment tool works in Photoshop.

TONE

The Tone button allows you to adjust the tonal range of the photo using a curves tool similar to that used in Photoshop. Control points can be added to the curve to refine the shape still further. Sliders that control contrast and the brightness of specific parts of the tonal range can be used as a simple alternative.

FOCUS

Digital photos tend to look soft if sharpening has not been applied in-camera *(see page 177)*. Focus allows you to sharpen up your photos. It also allows you to do the exact opposite and apply a soft-focus effect. This helps to soften your photos, giving them a hazy, romantic look as well as reducing the contrast slightly.

GRAIN

Digital photos can look too clean and smooth *(see page 104)*. The grain function in Exposure 3 helps to remove some of this smoothness and add a bit of grit to your photo. Grain can be added to selected tonal areas of the photo only and the degree of roughness altered.

IR

Infrared is a specialist area of black & white photography *(see page 126)* and Exposure 3 allows you to emulate the unique look of the process. One interesting effect of using IR film is the glow, known as halation, that occurs around bright objects. This is caused by light passing through the film and bouncing off the film back. This effect can be simulated in Exposure 3.

AGE

Film invariably suffers with handling. Dust and scratches slowly build up over time. This is not the case with a digital file from which an infinite number of perfect copies can be made. Therefore, why can't one of those copies be just a little bit scuffed and stained with age? Exposure 3 makes it easy to add a patina of wear to your photo.

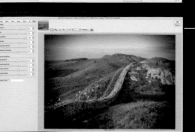

Beyond Photoshop

Although Adobe Photoshop is arguably the most well-known image editor available, there are alternatives. These range from cheap web-based applications to sophisticated standalone software.

Adobe Photoshop Elements

Elements is a far less expensive little brother of Photoshop. Many of the more sophisticated editing tools found in Photoshop are missing from Elements, but that does not mean that it is not a credible option to consider.

The black & white conversion tool is refreshingly simple to use, with presets that emulate the look of certain styles of photography, such as Infrared. Separate sliders allow you to adjust the amounts of red, green, and blue that are used in the conversion process, as well as the contrast of the photo.

Like Photoshop, Elements allows you to add adjustment layers to your photos. Elements even has the facility to add layer masks to selectively choose what part of the layer is visible and which part is transparent.

Elements also simplifies the task of importing photos straight from your camera. The latest versions of Elements support Adobe RAW and the DNG file format.

Why not try...?

The software that came with your camera. Most digital cameras will come supplied with a photo editor of some description. The sophistication of the editor generally depends on the cost of the camera, but black & white conversion is often an option.

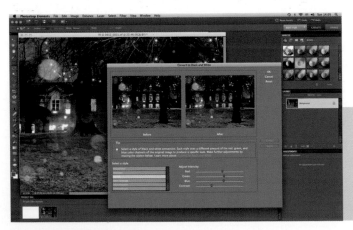

ELEMENTS 8
The latest version of Elements, showing the black & white conversion dialog box.

Lightroom

In addition to Photoshop, Adobe also produces Lightroom for Windows and Mac. Version 1 of Adobe Lightroom was first released in 2007 and has been continually updated since. At the time of writing, version 3 was available with many enhancements over the original release.

Lightroom is specifically aimed at photographers, and many of the tools found in Photoshop have Lightroom equivalents. Lightroom is also designed to help manage photos, including a system to apply keywords to photos, prepare photos for printing, and create a customizable slideshow.

Unlike Photoshop, Lightroom does not physically alter your photos as you adjust them. It is a non-destructive process in which a 'recipe' of adjustments is built up as you apply changes. It is therefore possible to return to your photos at any point and reinterpret them in a completely different way without losing any image quality.

What Lightroom arguably lacks over Photoshop is the ability to make accurate localized corrections to a photo. However, there was some degree of control introduced with the addition of the Graduated Filter and Adjustment brush tools in version 2.

Lightroom has a number of interesting tools to help you create black & white photos, including the ability to easily add a split toning effect *(see page 124)*. Like Photoshop, Lightroom also supports third-party plug-ins that can be used to expand the capabilities of the standard software.

Why not try...?
Aperture for the Apple Mac.

LIGHTROOM
The split toning effect is easier to achieve than in Photoshop.

Open-source software

A recent development has been the ready availability of open-source photo editing software. This software is either free or available for a small fee and is often as sophisticated as commercially developed editors such as Photoshop. Open-source software is usually written by enthusiasts and because of this updates aren't necessarily released on a regular basis. Support may also be lacking. However, open-source software has a devoted following and many problems can be resolved on the forums dedicated to the various editors.

GIMP

The GNU Image Manipulation Program is the most popular open-source photo editor. It was originally written for the UNIX operating system, but is now available for both Windows and Mac. GIMP is not promoted as a straight Photoshop replacement, though many functions, such as the ability to use layers, are comparable. Most major file formats are supported by GIMP, though importing RAW files for editing is not easy without some technical knowledge.

www.gimp.org

Photoscape

Photoscape takes a different approach to interface design to Photoshop and GIMP, and so may take some getting used to, if you're familiar with that style. That said, Photoscape is easy to use and well specified. There are options for converting color files to black & white and adding effects such as 'antique photo.' RAW files can be converted to JPEG for editing. Unlike GIMP, Photoscape is only available for Windows.

www.photoscape.org

GIMP *(Left)*
GIMP running on an Apple Mac OS X

PHOTOSCAPE *(Above)* The Photoscape intro screen.

Web-based software

Web-based applications are another alternative to commercial software. These applications run in your web browser, regardless of the computer platform that you use. The advantage of web-based applications is that they are in constant development, and any upgrades will be immediately and automatically available to you. There are several web-based photo editors that are free to use. At the time of writing, they lack the sophistication of software such as Photoshop, but this may well change as they develop.

Pixlr

Probably the most sophisticated of the web-based photo editors, the Pixlr interface is reasonably similar to Photoshop. Black & white conversion is, however, limited to a simple 'desaturate' option and creating a

half-tone effect. Although layers are supported with Pixlr, there is no equivalent to Adobe's adjustment layers.

www.pixlr.com

Sumopaint

Sumopaint is very similar in functionality to Pixlr, though with fewer options for photo effects. Black & white conversion is still limited to 'desaturate,' but there is scope for tinting and adding color to your black & white photos *(see page 120).*

www.sumopaint.com

Piknik

Less like Photoshop than Pixlr or Sumopaint, Piknik is a web-based application that integrates with your flickr picture sharing account if you have one. There is a variety of interesting effects that can be applied to your photos, such as sepia and film grain.

www.picnik.com

PIXLR
Pixlr running on an Apple Mac through Firefox.

CHAPTER 6　SPECIAL EFFECTS

Special Effects

Photographers have experimented with different visual styles and methods since the medium was invented. Photoshop, with its suite of tools, is the ideal application to expand your photographic repertoire.

Converting your digital photos to black & white and making basic tonal adjustments is just the start of the many alterations that can be made. Black & white photography is a far more expressive medium than color and a photo can be subject to a wide range of visual interpretations. It would be possible to ask a group of photographers to convert the same basic digital file and see widely differing results. What they will do is bring a bit of themselves to the task, and you should learn to see your photos as an extension of your personality.

In this chapter we'll explore some of these possibilities, referring back to traditional darkroom techniques when necessary. The various techniques can be mixed and matched so each example is not an end in itself. The key is to try each effect and see what most closely matches your personal style. Once you feel comfortable with an effect, try changing some of the settings. There are no right or wrong answers and experimentation is part of the fun.

You will get the best results working directly from your original RAW files. However, if you have shot in JPEG only, copy the files and work on the copies rather than on the originals. Once you've saved over the original, there's no going back and trying again.

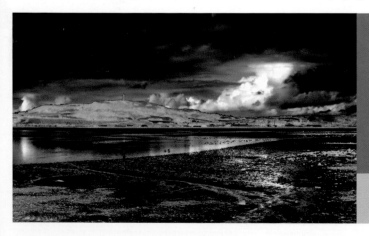

STRANGFORD LOUGH
The most appealing aspect of this scene in Northern Ireland was the wide range of tones in the sky and reflections in the water. I decided that a solarization effect *(see page 112)* would push this richness still farther.

Canon 1DS MkII, 50mm lens, 1/40 sec. at f/11, ISO 100

Photoshop Actions

Many of the effects described in this chapter are quite elaborate and take some time to complete. If you enjoy using a particular effect, it is worth saving the various processes involved as an 'action.' You will then be able to easily apply the same effect to other photos by running the action. An action is essentially a list of how you use Photoshop from the point at which you create a new action and start to Record. This automatic note-taking is halted when you press Stop. Once the action has been recorded, pressing Play will then apply exactly the same processes and settings to any other photo. Actions can be renamed for ease of identification and can be organized into different Sets.

To play an action, highlight the name of the action and press the Play button at the bottom of the palette. Individual processes can be temporarily removed from the action list by clicking on the check mark on the left edge of the palette. Clicking in the same place again adds the process back into the list. Double-clicking with the left mouse button on the action name will allow you to rename it.

Photoshop will retain your actions when you close the program, so they do not need to be saved. However, bear in mind that they are lost and cannot be retrieved once they have been deleted.

1 Stop playing/recording an action
2 Start recording an action
3 Play a recorded action
4 Create a new set
5 Create a new action
6 Delete an action

MY ACTIONS PALETTE
I have the Gum Bichromate technique recorded as an action for easy application to other photos *(see page 128 for more information on this technique)*. The action has been placed in a Black & White set along with other relevant actions.

Soft Focus

Sharpness through good technique is something to strive for in your photos. Or is it? Applying a soft focus effect will bring out the romantic side of your photography.

The most frequent use for a soft focus filter is hiding the wrinkles and blemishes on a person's face, traditionally the faces of women. Most filter manufacturers produce soft focus filters of varying strengths. However, breathing on a lens is another way of achieving a similar effect—though you do need to be quick! Another homemade approach is to stretch fine material such as pantyhose over the lens. Different colors of material would, of course, add in a color cast, though this is less of a problem if the photo is to be converted to black & white.

The one drawback to all these approaches is that once shot, you are committed to your photo having a soft focus quality. Using Photoshop to soften a sharp photo in post-production gets around this problem. The process described opposite will also allow you to selectively apply soft focus, a level of control that is almost impossible when creating the effect in-camera.

It is not just portraits that benefit from the application of a touch of soft focus. Landscapes and architecture also work well in soft focus, though you will need to pick your subject wisely. Photos with a high level of contrast will respond well to the technique. Misty scenes—already soft and low in contrast—less so.

BRIDGES OVER THE RIVER TYNE
Adding a soft focus effect to a lit cityscape works well. The less-attractive details are partially obscured by the effect and the lights gain an attractive and romantic glow.

Canon 5D, 200mm lens, 13 sec. at f/9, ISO 100

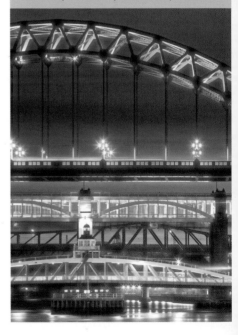

Applying digital soft focus

1) Open the black & white photo you want to add soft focus to.

2) Make a copy of the Background layer by dragging it down to the Create a new layer icon at the bottom of the layers palette.

3) Select **Filter/Other/Maximum**. Use the slider to select a radius. The radius you use will depend on the size of your photo. For a 14-megapixel photo, use a radius between 35 and 45. Use a smaller radius for smaller photos. Click on OK to continue.

4) Now select **Filter/Blur/Gaussian Blur**. Set the pixel radius to be half that used with the Maximum filter.

5) Set the opacity of your layer to between 20% and 40%, depending on how pronounced you want the soft focus effect to be.

6) Add a layer mask to your layer and use the brush tool to paint in any areas you want to remain sharp, using black as your foreground color.

7) Add a Curves adjustment layer at the top of the layer stack and adjust the contrast to suit.

8) When you are happy with the effect, flatten the photo and save.

QUEEN OF THE NIGHT
Each winter there is a celebration of light in Northumberland, England. This performer was rigged up in LED lights during one evening's event. Because the ambient light levels were low, I had to use a high ISO. To disguise the resulting grittiness, I applied the soft focus technqiue described above.

Canon 1DS MkII, 50mm lens, 1/30 sec. at f/1.8, ISO 800

Simulating film grain

Each year sees an increase in the quality of output from new digital sensors. Rather ironically, this often makes digital photographs look too 'clean,' and lacking the bite and texture of those shot on film.

Black & white negative film is composed of a plastic base coated in an emulsion of photosensitive silver halide crystals. When light strikes the crystals during exposure, they are chemically altered so that when the film is developed they are replaced by black (and therefore opaque) metallic silver. At the same time, the unexposed silver halide crystals are washed away, leaving those areas of the film clear. The sensitivity or speed *(see page 42)* of a film is determined by the size of these silver halide crystals. The larger the crystals, the more sensitive or faster the film, but also the more grainy the photographs will look.

The appearance of noise *(see page 43)* in a photo when ISO is increased on a digital camera is analogous to grain. However, digital noise is arguably less attractive than film grain, since it tends to be more regular in pattern.

Film grain has a pleasing randomness about it that is visually more interesting. Fast, grainy film is often used creatively with subjects that suit its gritty quality. Fine detail is lost when using grainy film, so simple and uncluttered compositions suit the medium well. There are commercial plug-ins for Photoshop *(see page 92)* that mimic the look of particular types of film, though film grain can be effectively replicated using the standard set of filters.

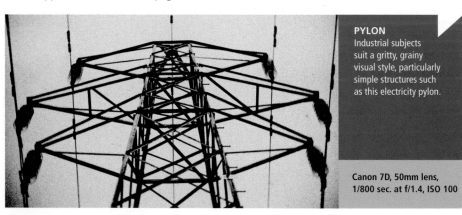

PYLON
Industrial subjects suit a gritty, grainy visual style, particularly simple structures such as this electricity pylon.

Canon 7D, 50mm lens, 1/800 sec. at f/1.4, ISO 100

Adding digital grain: method 1

1) Open the black & white photo you want to add grain to. Start with a photo that has little inherent digital noise.

2) Select **Filter/Noise/Add Noise**.

3) Select Monochromatic at the bottom of the dialog box.

4) Select either Uniform or Gaussian distribution.

The difference between the two options is more important when adding noise to color photos, and which you choose for this exercise is more a matter of taste.

5) Move the Amount slider left to decrease the amount of noise, right to increase the amount of noise in your photo. The greater the amount, the more the detail in your photo will be lost.

6) When you're happy with the amount of noise you will add to the photo, click OK.

7) If, after clicking OK, you decide you want to decrease the effect of the noise added, select **Edit/Fade/Add Noise**. Use the Opacity slider to vary how heavily the noise affects the photo. The smaller the opacity value, the less the effect of the Add Noise filter.

8) Save the photo.

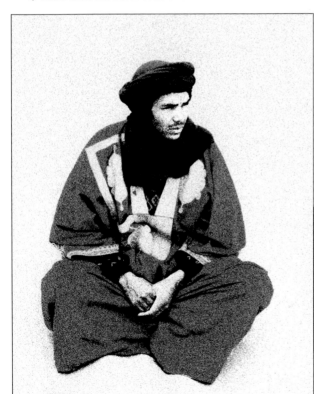

TUAREG
More often than not, men suit the grainy treatment better than women. I added grain to this photo of a traditionally dressed Tuareg male, from the Saharan interior of North Africa, to invoke the grittiness of desert life.

Pentax 67II, scanned film, exposure details unrecorded

Adding digital grain: method 2

1) Open the black & white photo you want to add grain to.

2) Add a Hue/Saturation adjustment layer to the photo. Set saturation to -100 (this will keep the photo as black & white when grain is added).

3) Select the photo layer (this will typically be called Background, unless you've changed the name).

4) Select **Filter/Texture/Grain**.

5) There is a variety of grain effects that can be applied to your photo from the Grain Type drop-down menu. There are some effects that are more natural looking than others. Don't be afraid to experiment, but for this exercise choose Enlarged.

6) Use the Intensity slider to vary the intensity of the grain. The greater the Intensity value, the greater the

effect and the greater the loss of detail there will be.

7) Adjust the Contrast slider to suit. Leave the contrast value set at 50 if you do not want to change the contrast. At 0, your photo will be decreased by the application of the Grain filter; at 100, the contrast in your photo will be increased. Fast (and therefore grainy) film generally has lower contrast than a slow, finer-grained film, so don't overdo the contrast if you want to emulate the fast film look.

8) Click OK to apply the filter.

9) If, after clicking OK, you decide you want to decrease the effect of the noise added, select **Edit/Fade Grain**. Use the Opacity slider to vary how heavily the grain affects the photo. The smaller the opacity value, the less the effect of the Grain filter.

10) Save the photo.

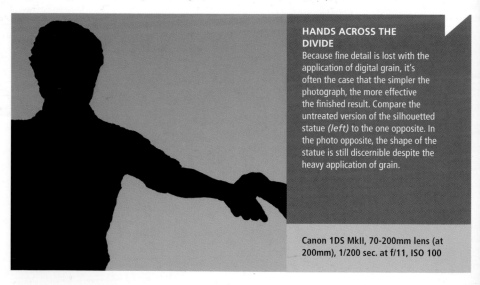

HANDS ACROSS THE DIVIDE
Because fine detail is lost with the application of digital grain, it's often the case that the simpler the photograph, the more effective the finished result. Compare the untreated version of the silhouetted statue *(left)* to the one opposite. In the photo opposite, the shape of the statue is still discernible despite the heavy application of grain.

Canon 1DS MkII, 70-200mm lens (at 200mm), 1/200 sec. at f/11, ISO 100

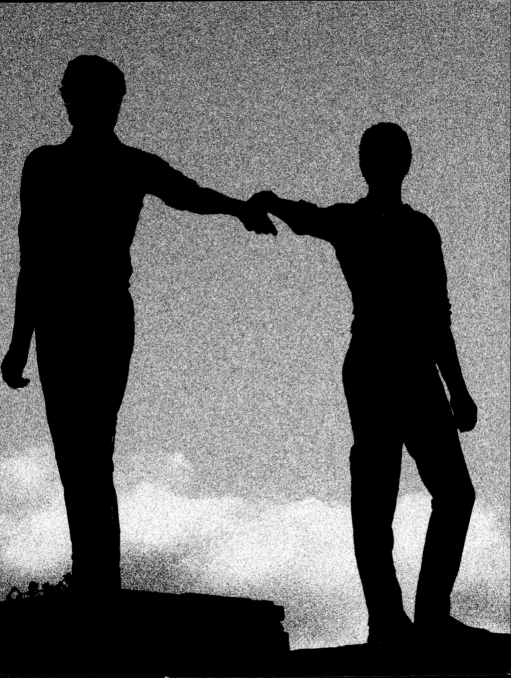

Toning

A black & white photograph doesn't need to be purely shades of gray. Toning a photograph using a variety of chemicals to create an overall color tint was common practice in the darkroom.

The most familiar type of toning is sepia, a pigment made from the ink of the cuttlefish. Anyone with a collection of old photos will instantly recognize sepia's warm, brown tint. Although almost a cliché, sepia toning has a practical purpose.

When a darkroom print is toned, the metallic silver in the photo is converted to another compound. In the case of sepia, the compound is a sulphide. Toning a print often improves the archival properties by making the compounds in the print more stable and resistant to atmospheric effects. Digitally toning a photo will not increase its ability to resist fading when printed, but if used imaginatively and subtly it will enhance the effectiveness of your photograph.

The art of toning is to choose a color that adds to your picture rather than detracting from it. A warm tone would not necessarily enhance a cold subject, and vice versa. This applies to both temperature and to the emotional atmosphere you wish to convey. It also pays to be subtle; a more delicate toning approach is often more pleasing than over-saturating your photo.

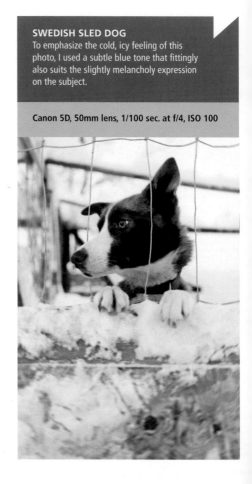

SWEDISH SLED DOG
To emphasize the cold, icy feeling of this photo, I used a subtle blue tone that fittingly also suits the slightly melancholy expression on the subject.

Canon 5D, 50mm lens, 1/100 sec. at f/4, ISO 100

Applying digital toning

1) Open a black & white photo.

2) Add a Hue/Saturation adjustment layer to the photo.

3) Select the Colorize option on the Hue/Saturation dialog box.

4) For a sepia-toned photo, pull the Hue slider to the left to 40, change the Saturation value to 20, and leave Lightness at 0.

5) For a cold blue tone, move the Hue slider to the right to 225, change the Saturation value to 20 again and leave Lightness at 0.

6) Click on OK once you are happy with the effect.

7) Flatten the photo and save.

Why not try...?
Building up a series of linked photos that are similarly toned, as a long-term project.

A TOUCH OF SEPIA
Beamish Museum features a recreation of an early-20th-century English town. I found these oil cans in the car workshop at the museum and felt the resulting photo suited sepia toning.

Canon 5D, 17–40mm lens (at 40mm), 1/13 sec. at f/4, ISO 1250

Aging your photos

One of the attractions of black & white photography is its timeless quality. This can be pushed to the extreme by artificially 'aging' your photos.

There are several ways in which a photo begins to show the effects of age. Ironically, light will have an adverse effect on a printed photograph. Over time, exposure to light will begin to fade a print, reducing the overall contrast. If the photo is handled often, it will begin to pick up scratches and marks.

Old photos also have an interesting visual quality due to the film type and cameras they were created with. Often old photos were shot with lenses that were less sharp than their modern counterparts. This softness particularly affected the corners of the photo. Old film types were often very slow too *(see page 42)* and so the camera lens would need to be set to maximum aperture to achieve a reasonable shutter speed. This also contributed to the edge softness of the resulting photo. Using a wide aperture also causes vignetting, where the corners of a photo are darker than the center. Artificially recreating all or some of these effects will help you to create a convincing 'old' photo.

FISHING BOAT
This fishing boat looks weather and time worn. The color version was interesting, but the black & white 'aged' conversion has far more atmosphere.

Canon 7D, 50mm lens,
1/25 sec. at f/10,
ISO 100

Digital photo aging

1) Open the black & white photo you want to age and follow steps 2 to 6 on page 109 to create a sepia effect.

2) Add a Curves adjustment layer. As photos age, they start to lose contrast and become flatter in appearance. Adjust the curve to reduce the contrast and lighten the photo. Click OK when you're finished.

3) Select the photo layer (this will typically be called Background, unless you've changed the name).

4) To simulate lens softness, select **Filter/Blur/Radial Blur**. Set the blur method to Spin, Quality to best, and Amount to 1. Select OK to continue. The edges of the photo should now be soft, but the center left relatively unaffected.

5) Another characteristic of old photos is a darkening of the corners. To add this effect to your photo, select **Filter/Lens Correction**. Pull the Vignette slider to the left to darken the corners. There is no correct value, only personal taste. Select OK to apply the filter.

6) Finally, to mimic the graininess of an old photo, select **Filter/Texture/Grain**. Select **Grain Type/Soft** from the drop-down menu. Set Intensity to 40 and Contrast to 50. These values are a good starting point to simulate film grain, but it is worth experimenting to find settings that appeal to you *(see page 104 for further information about adding film grain)*. Select OK to apply the filter.

7) Flatten the photo and save.

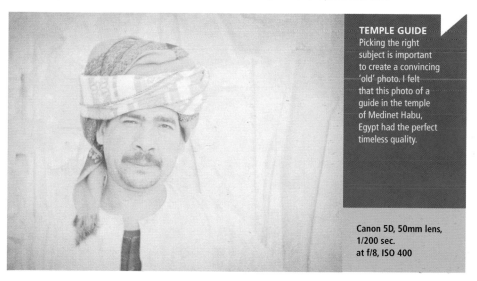

TEMPLE GUIDE
Picking the right subject is important to create a convincing 'old' photo. I felt that this photo of a guide in the temple of Medinet Habu, Egypt had the perfect timeless quality.

Canon 5D, 50mm lens,
1/200 sec.
at f/8, ISO 400

Solarization

A solarized photo is one that has had part of the tonal range reversed so that dark areas become light or vice versa. The technique was perfected by the photographers Man Ray and Lee Miller in the 1930s.

The effect of solarization was first discovered in the 19th century when extreme overexposure of a negative would cause the highlights to be rendered as black or dark gray when a positive print was made. The name came from the fact that this effect was most often observed when creating photos that included the sun. The effect was refined and made more repeatable by Ray and Miller by briefly exposing a print to a bright light source during development of the print.

Overexposing a digital file in-camera has no equivalent effect. Once the highlights of the photo have been clipped, they remain clipped and therefore pure white. It is only by using a photo-editing tool such as Photoshop that a similar effect can be created digitally. The easiest was to achieve a solarized photo digitally is to use a curves adjustment. Curves will allow you to radically alter a proportion of the tonal range while minimizing the effect on other tones.

Why not try...?
Joining one of the solarization groups on picture sharing web site flickr.

WHITE SILHOUETTES
Solarization was embraced by surrealist artists such as Man Ray because of its otherworldly effect on otherwise normal photos. Here, I created a black sky and white silhouettes by reversing the curve shown on the page opposite.

Canon 7D, 17–40mm lens (at 40mm), 1/1600 sec. at f/11, ISO 100

Digital solarization

1) Open the black & white photo you want to solarize. A simple design with well-defined areas of light and dark will generally produce the most effective results.

2) Add a Curves adjustment layer to the photo.

of the original points on the curve or add more adjustment points and move them around to create a more complex curve shape.

8) Click on OK once you are happy with the solarization effect.

9) Flatten the photo and save.

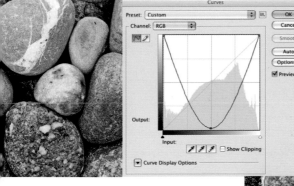

PEBBLES

Though I was happy with the original black & white photo, I felt there was more I could do to add punch. Solarizing the photo, inverting the dark tones in the shadows, added the extra element I was looking for.

Canon 7D, 70–200mm lens (at 200mm), 1/18 sec. at f/18, ISO 100

3) Now add an adjustment point midway along the output curve.

4) Pull either the left (black) end of the curve upward so that the output is 255, or pull the right (white) end of the curve downward so that the output is 0.

5) Now pull the midway adjustment point in the opposite direction so that the curve is shaped like a bell curve.

6) A U-shaped curve will cause the tones in the photo that are darker than mid-gray to become progressively lighter, with pure black becoming pure white, but leaving the original light tones unaffected. An inverted U curve will produce the opposite effect.

7) To refine the effect, adjust either the position

Cyanotypes

This alternative process has a history stretching back to the mid-19th century. As the name suggests, cyanotype photos are notable for their subtle cyan-blue tones.

The cyanotype process was developed by the English astronomer Sir John Herschel. Rather than using silver, the cyanotype process uses a mix of iron salts (usually ferric ammonium citrate) and another chemical (such as potassium ferricyanide) as a photosensitive medium.

When exposed to ultraviolet (UV) light, the reaction of these two chemicals produces Prussian Blue, the color that gives the cyanotype its distinctive hue. The length of exposure to UV light determines the depth of the blue that is produced.

The trick to producing a convincing digital cyanotype is recreating the Prussian Blue. The RGB value that most closely matches Prussian Blue is 00,31,53—and this is the tone of blue and level of color saturation you should aim for. However, this value should only be used as a starting point and there is no reason why digital cyanotypes shouldn't be more or less vivid.

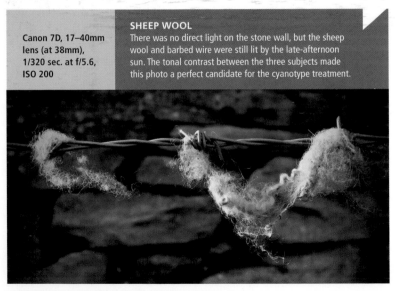

Canon 7D, 17–40mm lens (at 38mm), 1/320 sec. at f/5.6, ISO 200

SHEEP WOOL
There was no direct light on the stone wall, but the sheep wool and barbed wire were still lit by the late-afternoon sun. The tonal contrast between the three subjects made this photo a perfect candidate for the cyanotype treatment.

Creating digital cyanotypes

1) Open the color photo you want to convert to a cyanotype. A simple design with a good contrast range will generally produce the most effective results.

2) Add a Channel Mixer adjustment layer to the photo.

3) Check the Monochrome button at the bottom of the options dialog box.

4) Move the sliders to mix the proportions of the red, green, and blue channels to give the most pleasing result. A greater proportion of blue to red and green will give a more authentic cyanotype look. However, a mix of more than 100% of all the channels combined will cause detail to be lost in the highlights of the photo.

5) Click on OK.

6) Add a Curves adjustment layer to the photo above Channel Mixer.

7) Select the red channel from the drop-down menu and pull the curve down.

8) Select the blue channel and this time push the curve up.

9) Click on OK once you are happy with curves adjustments.

10) Add a new layer directly above the background layer. Set the foreground color to R:00, G:31: B: 53. Fill the layer with this color and then set the layer blend mode to 'Color.'

11) Flatten the photo and save.

IRISES
Particular care needed to be taken with the channel mixer setting, since I wanted the flowers to be much lighter than the background. I found that the proportions of red +25%, green 0% and blue +75% gave the most pleasing effect.

Canon 7D, 70–200mm lens (at 200mm), 1/50 sec. at f/4, ISO 500

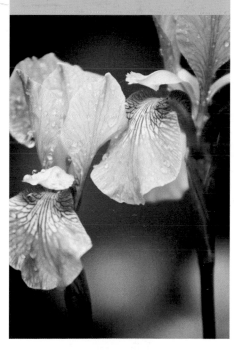

Photograms

A photogram is a method of creating a photo without using a camera. The technique was particularly popular with the surrealist movement in the early 20th century.

Photograms were first created by William Henry Fox Talbot when he placed leaves and other objects on light-sensitive paper. After exposure to light, the uncovered area of the paper would turn black, leaving the covered areas white (or a variety of shades of gray depending on the translucency of the objects used). This technique was further refined by Man Ray when he used a darkroom to create his 'rayograph' series of photos (rayograph is essentially another word for photogram and is often used interchangeably).

Digital photograms

Using a flatbed scanner is the easiest way to create a digital photogram. There are two methods. The first, creating a negative photogram, works well with solid, hard-edged objects. The second, creating a positive photogram is particularly effective with soft, organic even translucent subjects. Flatbed scanners are generally robust, but it's important to note that anything heavy enough to break or damage the glass of the scanner should not be used.

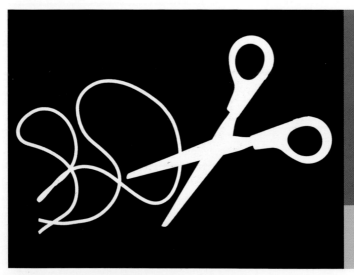

SNIP! SNIP!
Even with a simple setup, it's possible to tell a story as with this pair of scissors cutting a length of string.

Epson 4990 flatbed scanner, scanned at 1200ppi

Creating a negative photogram

1) For this project you will need a flatbed scanner with a transparency-scanning hood. Though not essential, it is worth cleaning the glass plate of the scanner before starting to remove any extraneous marks.

2) Place the object(s) you want to use to create the photogram on the glass plate of your scanner. Be careful not to scratch the glass of the scanner if the objects are hard or sharp.

3) Remove the cover for the transparency hood in the lid of the scanner and lower the lid of the scanner down.

4) Launch the software you usually use to make a scan.

5) Set the scanning mode to Film or similar and preview the scan.

6) Use the scanning software to frame the preview photo as required and then make the scan.

7) Open the scanned photo in Photoshop.

8) Remove the colors from the photo by selecting **Image/Adjustments/Desaturate**.

9) Add a Curves adjustment layer to the photo and increase the contrast to remove all the tones except black & white.

10) Add an Invert adjustment layer to the photo to reverse black & white. This should make the background black and the silhouettes of your scanned objects white.

11) Flatten the photo and save.

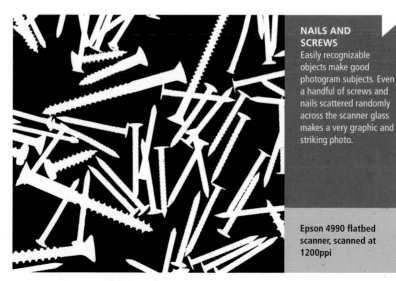

NAILS AND SCREWS
Easily recognizable objects make good photogram subjects. Even a handful of screws and nails scattered randomly across the scanner glass makes a very graphic and striking photo.

Epson 4990 flatbed scanner, scanned at 1200ppi

Creating a positive photogram

1) For this project you will need a flatbed scanner. Though not essential, it is worth cleaning the glass plate of the scanner before starting to remove any extraneous marks.

2) Place the object(s) you want to use to create the photogram on the glass plate of your scanner. Be careful not to scratch the glass of the scanner if the objects are hard or sharp.

3) Carefully place a piece of black cloth or paper over the objects on the scanner or leave the lid of the scanner raised.

4) Launch the software you usually use to make a scan.

5) Set the scanning mode to Reflective or similar and preview the scan. If you leave the lid of the scanner raised in step 3, do not look directly at the light of the scanning head.

6) Use the scanning software to frame the preview photo as required and then make the scan.

7) Open the scanned photo in Photoshop.

8) Use your preferred method to convert the photo to black & white and make any required tonal adjustments. Ideally the background should be pure black.

9) Add an Invert adjustment layer to the photo to reverse the tones. This should make the background white and the scanned objects shades of gray.

10) Flatten the photo and save.

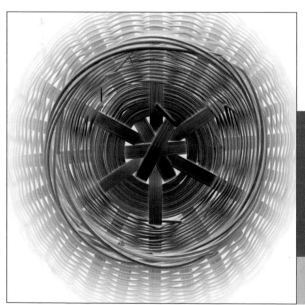

BASKET
One of the appealing results of using a flatbed scanner is how shallow the depth of field is and also how quickly the scanning light fades away the more three dimensional the object. This was the case with the wooden basket I used for this photo.

Epson 4990 flatbed scanner, scanned at 1200ppi

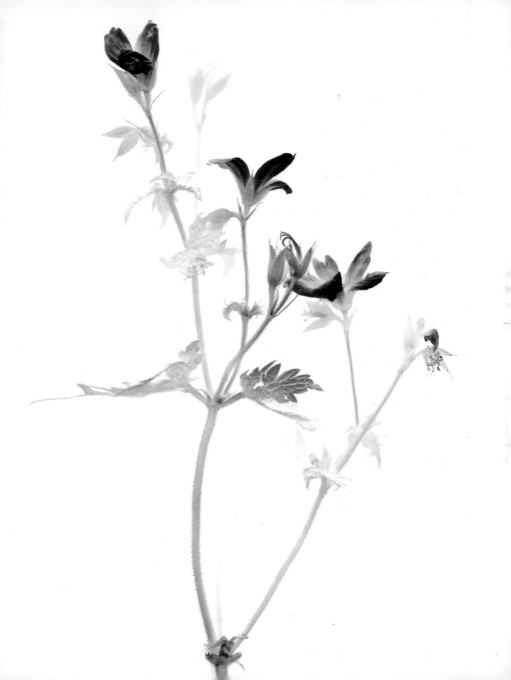

A Splash of Color

Before the invention of the color photographic process, color was added to photographs by hand using special oil paints. In the right hands, the result was a delicate blend of photography and art.

It may seem slightly perverse to add color back into your carefully converted black & white photo. However, recoloring a photo allows you to be as literal or as abstract with color as you like. It's not even important to be precise when applying color. Ignoring boundaries and allowing color to bleed from one area to another will give your photographs a hand-crafted look.

Of course the entire photo does not need to be colored. Using color selectively is a good way to focus attention on one particular part of your photo. A single object in bright primary colors will leap out from a monochrome background.

Adding color

1) Open a black & white photo.

2) Add a new layer to your photo and set the blend mode to Color.

3) Select the Brush tool. Change the hardness and size of the brush if necessary. The smaller and harder the brush, the more delicate your painting will be. Set the brush opacity to 25%.

4) Choose a suitable foreground color using the color picker or swatch palette and paint over the area of your picture you want to add color to.

5) If you make a mistake, use the Eraser tool to remove unwanted color.

6) Continue painting, changing brush size and color as appropriate.

7) Flatten the photo and save.

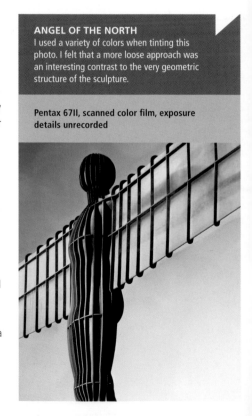

ANGEL OF THE NORTH
I used a variety of colors when tinting this photo. I felt that a more loose approach was an interesting contrast to the very geometric structure of the sculpture.

Pentax 67II, scanned color film, exposure details unrecorded

Subtracting color

1) Open a color photo. One with a discrete and brightly colored subject is preferable.

2) Use the Magnetic Lasso tool to draw a selection around the subject. Don't worry if the selection isn't exact at this point.

3) Once you've made the selection, invert it by going to **Select/Inverse**.

4) Add a Black & White adjustment layer to the photo. Select the most effective conversion preset for your particular photo.

5) Now the subject of your photo should be the only element still in color. Everything else should be in black & white.

6) If the boundary between the color and black & white areas needs refining, click on the Channels palette and then on the Black & White mask. The subject of your photo should now be covered in a semi-opaque color.

7) Zoom into the area that you want to adjust and select the Brush tool. Set Opacity of the brush to 100%, change the size if required, and set the foreground color to black (R:00, G:00, B:00). Paint the areas of the subject that are not covered in the semi-opaque color.

8) When you are finished, select the RGB channel in the Channels palette and turn off the Black & White mask by clicking on the eye symbol on the left of that channel.

9) Select the Layers palette, flatten the photo, and then save.

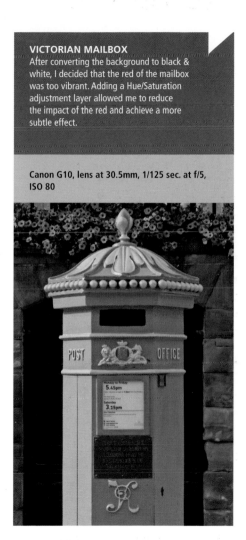

VICTORIAN MAILBOX
After converting the background to black & white, I decided that the red of the mailbox was too vibrant. Adding a Hue/Saturation adjustment layer allowed me to reduce the impact of the red and achieve a more subtle effect.

Canon G10, lens at 30.5mm, 1/125 sec. at f/5, ISO 80

Texture

Overlaying a texture onto your photo will help to give it more 'bite.' Textures can be found everywhere and captured using a camera or scanner, or created in Photoshop. The only limit is your imagination.

It's theoretically possible to coat any material with a light-sensitive chemical emulsion, project an image onto the surface, and create a print in the darkroom. If the surface were textured, the texture would become part of the photo, and if chosen wisely would add an interesting quality to the image. This is less easy to achieve digitally. Inkjet printers are far less forgiving of what goes through them than a bath of developing fluid. There are textured papers suitable for inkjet printing, but they are still relatively smooth to avoid damaging the heads of your printer.

The next best thing is to convey the illusion of texture. Fortunately, this is very easy to achieve in Photoshop. First decide on the type of texture you'd like to overlay on your photo. A texture with lots of contrast will be more effective than a flatter one. Textures can be captured with your camera or with a flatbed scanner, or created from scratch in Photoshop. The texture can be as complex and deep as the bark of a tree or as simple as paper roughly crumpled and then flattened and scanned. The type of photo you add texture to will make a difference. This technique works well with simple, uncluttered photos. A photo that is too busy will make it difficult to see the added texture.

WINTER CHILL
I wanted to enhance the cold feel of this photo of bare trees in winter. To do this, I overlaid a photo of ice patterns and added an overall blue tone.

Canon G10, lens at 6.1mm, 1/1000 sec. at f/5.6, ISO 80

Creating a Quick Photoshop Texture

1) Select **File/New** to create a new document. Set the pixel dimensions to match the photo you want to add texture to. Click OK to continue.

2) Set the Foreground and Background colors to white (R:255, G:255, B:255) and black (R:0, G:0, B:0) respectively.

3) Select **Filter/Render/Clouds.** The document should now be filled with a random cloud effect.

4) Save the texture for future use.

Adding Texture

1) Open the photo you want to add texture to.

2) Open or create a photo that you want to use as the texture. If necessary, convert it to black & white and resize it so that pixel dimensions match your target photo.

3) Use the move tool to drag the texture into a new layer on your target photo. Holding down the shift key as you drag the texture will snap it precisely into place on your target photo.

4) Use the Opacity slider on the Layer palette to vary how much the texture affects your photo. The lower the opacity value, the more subtle the texture effect will be.

5) Once you are happy with the look of your photo, flatten the layers and save.

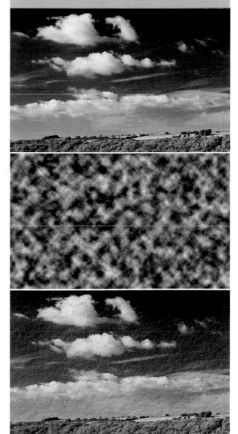

CLOUDSCAPE
Adding a texture of a stone surface introduced interest to this large expanse of sky.

Canon 7D, 17–40mm lens (at 40mm), 1/100 sec. at f/6.3, ISO 100

Split-toning

A traditional darkroom technique, split-toning involves using two separate chemical washes to tint the highlights and shadows in two different colors.

Effective split-toning is one of the more difficult darkroom effects to achieve. The technique involves washing a print in toner after it has been developed normally. Chemical solutions used range from sodium thiocyanate to gold chloride. Each chemical toner tints the print a different color. The effect is varied still further by the amount of time the print sits in the toning bath. The longer the bath, the more pronounced the colors. These chemicals are usually safe when handled respectfully. The general advice is to wear gloves and work in a well-ventilated room. Fortunately, the digital version of this technique has far less potential for personal harm!

The most interesting split-toning involves employing two tones that are distinct from one another, such as using a warm tone and a cool tone together. The effect can be as gaudy or as subtle as you like. My personal preference is for a subtle approach, with a warm set of highlights and a cooler range of shadow tones. However, as with so much of photography, there is no right or wrong answer. Experimentation is the key to find out what works for you and each individual photo.

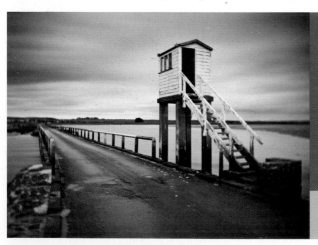

CAUSEWAY
I used a 10-stop ND filter to artificially extend the shutter speed of this shot. It was an overcast day and the movement of the clouds has been captured during the exposure. In Photoshop, I then darkened the corners and used blue-gray for the shadow tones to draw the eye to the refuge hut on the right.

Canon 7D, 17–40mm lens (at 17mm), 90 sec. at f/18, ISO 100

Digital split-toning

1) Open the black & white photo you want to split-tone. This technique will work with any photo that has a wide tonal range.

2) Add a Hue/Saturation adjustment layer to the photo, but do not make any changes to the default values at this stage. Rename the layer Shadow.

3) Add a second Hue/Saturation adjustment layer above the first, but again do not make any changes to the default values. Rename the layer Highlight.

4) Click on the layer mask of the Highlight layer to select it and then go to **Photo/Apply Photo**. Leave the default values as they are and click OK.

5) Double-click on the Hue/Saturation icon on the Highlight adjustment layer. Select the Colorize option on the dialog box. Adjust the Hue slider to tint the highlights in your photo to the desired color. Click OK.

6) Click on the layer mask of the Shadow layer to select it and then go to **Photo/Apply Photo**. Leave the default values as they are and click on OK. Now select **Image/Adjustments/Invert** to invert the layer mask.

7) Double-click on the Shadow adjustment layer Hue/Saturation icon. Select the Colorize option on the dialog box. Adjust the Hue slider to tint the shadows in your photo the desired color. Click OK.

8) To adjust the balance of colors between the two adjustment layers, select either of the two layer masks and then use **Image/Adjustments/Levels** to change the density of the layer mask. Darkening the Highlight layer mask will reduce the effect of the highlight color. Lightening the Shadow layer mask will reduce the effect of the shadow color.

9) When you are happy with your adjustments, flatten the photo and save.

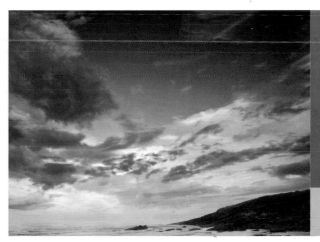

HOWICK COAST
Interesting cloudscapes make particularly good subjects for the split-toning technique. This sky above the Northumberland coast at Howick has a good tonal range due to the way the different cloud layers are lit.

Canon 5D, 24mm lens, 1.3 sec. at f/16, ISO 50

Infrared

Visible light is just one part of the electromagnetic spectrum that can be used to create photos. Infrared photography has long been popular due to the dreamlike quality of the photos.

Infrared (or IR) photography uses the part of the spectrum from 700 nm to 900 nm. This light is invisible to the human eye, but is abundant in sunlight, making landscapes a popular subject for IR photography.

IR photography is particularly effective when shooting subjects that either emit IR light or naturally reflect this portion of the spectrum. Green foliage is a good example of a subject that reflects IR light well. In black & white photography, this results in foliage being rendered in very pale tones, sometimes completely white.

Rather ironically, digital sensors are very sensitive to IR light, so camera manufacturers have designed various ways to reduce the effect of IR on your photos. There are third-party companies that will modify your camera to be sensitive to IR, though this is not something you will be able to undo without further specialized and expensive work.

Another option is to buy a filter that fits on your camera lens. These filters block visible light and only allowing through IR light. Using filters increases exposure times and so they are only useful for static subjects. Fortunately, it is possible to recreate the look of an IR photo in Photoshop.

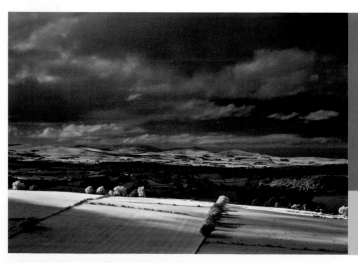

VIEWPOINT
This photo was shot with an IR-modified DSLR. In true IR photos, trees can look almost sugar-coated when lit by strong sunlight. The chlorophyll in leaves is a strong reflector of IR light.

Canon 30D, 17–40mm lens (at 40mm), 1/5 sec. at f/14, ISO 100

Digital Infrared

1) Open the color photo you want to convert to infrared. This technique is particularly effective with foliage-rich landscape photos.

2) Infrared photos are generally very grainy. To simulate this, select **Filter/Add Noise** and set the noise value to 5. Click OK to continue.

3) Next add a Channel Mixer adjustment layer to the photo.

4) Check the Monochrome button at the bottom of the options dialog box.

5) Getting the right proportions of red, green, and blue takes some experimentation. Start with the values, red -50, green +200, blue -50. If any of the tones in your photo start to look as though they are brighter than white, lower the Constant slider value to compensate for this. The effect you are looking for is that the blues in the photograph

darken considerably and any greens become lighter. When you are satisfied with the effect, click on OK to continue.

6) Flatten the photo.

7) Duplicate the background layer twice.

8) Set the blend mode of the upper duplicated layer to Screen.

9) Set the blend mode of the lower duplicated layer to Linear Burn.

10) Flatten the photo again and save.

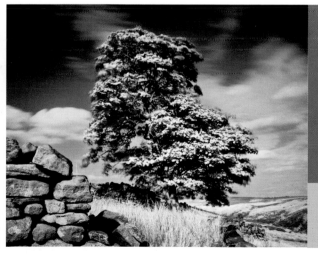

YORKSHIRE MOORS
Another effect of IR is the darkening to almost black of blue skies. This is particularly striking when there is a scattering of cloud.

Canon 7D, 17¬40mm lens (at 40mm), 30 sec. at f/13, ISO 100, 10 stop ND

Gum Bichromate

The process is associated with the Pictorialism movement of the late 19th century. The aim of the Pictorialists was to emulate the techniques of non-photographic art forms such as painting.

The beauty of the gum bichromate process was its manipulability. During the creation of a gum bichromate print, details in the photograph could be altered by using a brush or erased entirely, and levels of contrast and tone finely tuned. Each print made using the process would therefore be unique and irreproducible. This fulfilled the goal of the Pictorialists that photography be an art rather than a purely mechanical process.

The technique used here to emulate the gum bichromate process should only be viewed as a starting point. Experiment with different effects such as selectively blurring elements in your photos, or overlaying different sorts of textures. The beauty of the gum bichromate method is that there is no right answer—only what you believe to be aesthetically pleasing.

As a final touch, choosing which paper to print your photo onto will make a considerable difference. The more textured the paper, such as a rough watercolor paper, the more this will emphasize the artistic impact of the photo.

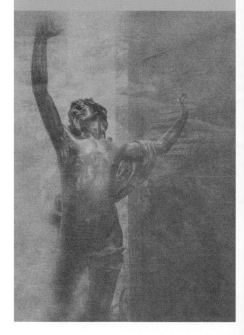

ETHEREAL STATUE
I wanted a soft-focus effect around the statue to draw the eye to the face and chest. Before applying the technique opposite, I used the Blur tool and roughly painted around the figure.

Canon 1DS MkII, 17–40mm lens (at 30mm), 2 sec. at f/14, ISO 100

Creating a digital gum bichromate

1) Open the black & white photo you want to convert to a gum bichromate. This process is particularly effective with naturally soft photos.

2) Add a Gradient Map adjustment layer to the photo. Add a new gradient by clicking on the gradient strip in the adjustment layer's dialog box. When the Gradient Editor is displayed, type Gum Bichromate into the Name field and select New.

3) Double-click on the color stop, below the gradient strip, on the far left. When the Select stop color dialog box is displayed, set the RGB values to R:82, G:68, B:54. Click on OK to return to the gradient editor.

4) Now double-click on the color stop on the far right. When the Select stop color dialog box is displayed, set the RGB values to R:194, G:190, B:155. Click on OK to return to the gradient editor. Close the gradient editor by clicking on OK and again to exit from the Gradient Map dialog box.

5) Set the foreground color to R:200, G:200, B:200 and the background color to R:140, G:140, and B:140.

6) Add a new blank layer and, using the Fill tool, fill the layer with the foreground color. Select **Filter/Render/Clouds** to fill the layer with a random blotchy texture. Set the blend mode of the layer to Overlay and the opacity to 30%.

7) Add a new blank layer and, using the Fill tool, fill the layer with the foreground color. Select **Filter/Noise/Add Noise**. Set the amount to 80% and

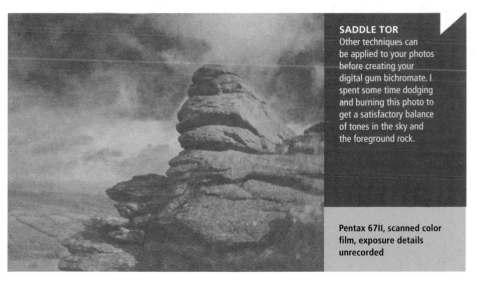

SADDLE TOR
Other techniques can be applied to your photos before creating your digital gum bichromate. I spent some time dodging and burning this photo to get a satisfactory balance of tones in the sky and the foreground rock.

Pentax 67II, scanned color film, exposure details unrecorded

check the Monochromatic option. Click OK to exit. Select **Filter/Blur/Gaussian Blur**. Set the blur radius to 4 pixels and click OK to exit. Set the blend mode of the layer to Overlay and leave the opacity at 100%.

8) Click on Add Layer Mask. Select **Photo/Apply Photo** and set Layer to Background in the drop down menu. Click OK to exit.

9) Add a new blank layer and, using the Fill tool, fill the layer with the foreground color. Select **Filter/Noise/Add Noise.** Set the amount to 80% and check the Monochromatic option. Click OK to exit. Select **Filter/Blur/Motion Blur**. Set the angle to 45° and Distance to 5 pixels. Click OK to exit. Select **Filter/Blur/Motion Blur** again. Set the angle to -45° and Distance to 5 pixels. Click OK to exit. Set the blend mode of the layer to Overlay and leave the opacity at 100%.

10) Click on Add Layer Mask. Select **Photo/Apply Photo** and set Layer to Background in the drop-down menu. Click OK to exit. Select **Image/Adjustments/Invert**.

11) As a further refinement, add one more layer to the photo. Copy and paste a textural photo (such as a photo of stone or cloth) the same size as your photo into this layer. Set the blend mode to Overlay and adjust the opacity to suit.

12) Flatten the photo and save.

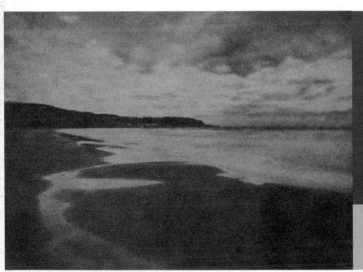

ANTRIM COAST
The sky was overcast and there was a chill wind blowing along the beach the night I created this photo of White Park Bay in Northern Ireland. Using a blue tone and the gum bichromate process helps to convey my feelings on the night of the shoot.

Canon 1DS MkII, 17–40mm lens (at 24mm), 3.2 sec. at f/16, ISO 100

STONE TOWN
The largest town on the island of Zanzibar has a timeless quality
perfectly suited to the pictorial qualities of the gum bichromate process.

Printing Effects

Photoshop can be used to emulate a variety of effects achieved by mass-production printing processes. These techniques can lift a photo from ordinary to arty with a few clicks of the mouse.

Halftone pattern

Using one ink color only is perfectly adequate when printing text, but is a severe limitation when a photo needs to be reproduced. This problem was solved in the 19th century by the invention of the halftone technique. A photo is broken down into a series of small dots that vary in size and density across a page. It is this variation that causes the optical illusion that a one-color photo is comprised of many different shades. The technique is still used today when printing, despite the advances in technology over the past century. The halftone look has been used by artists such as Roy Lichtenstein to celebrate its use in pop culture. Using it on your own photos will add a more graphic look that, with the right image, is very appealing.

Photocopy

The standard photocopier is a familiar piece of office equipment and its potential as a medium to create visually interesting images is mostly overlooked. A copy is never identical to an original, since defects are always added in. Copy the copy, and repeat that process and the results begin to drift farther from the original with each iteration. While this is not acceptable if you want a perfect copy, it is an intriguing characteristic if you want to create an image with a difference. It is particularly effective

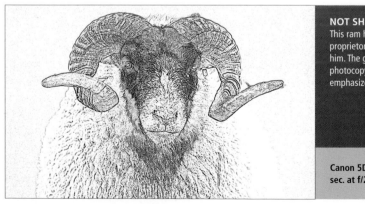

NOT SHEEPISH
This ram has a very proprietorial air about him. The grittiness of the photocopy filter helps to emphasize this.

Canon 5D, 200mm lens, 1/500 sec. at f/2.8, ISO 640

with high-contrast, slightly gritty images, the copying process enhancing those qualities. The Photoshop photocopy filter will allow you to mimic this process—though with less potential for office gossip gleaned while standing around the photocopier!

Creating a digital halftone

1) Open the black & white photo you want to convert to a halftone.

2) Set the foreground color to black and the background to white. You can also use shades of gray; the closer the tonal values of the foreground and background the less contrast there will be in the final halftone photo. If the foreground color is lighter than the background, the photo will be turned into a negative.

3) Select **Filter/Sketch/Halftone Pattern**.

4) Adjust the Size slider to increase or decrease the size of the halftone dots. The larger the dots, the less detail will be preserved in the final photo.

5) Adjust the Contrast slider to increase or decrease the tonal range of the halftone dots. A high contrast setting will result in a more 'comic book' style of photo.

6) Select a pattern type from the drop-down menu. Dots most resembles the way a newspaper photo is created. Line gives a venetian-blind effect to your photo. Circle is similar, with the lines radiating out from the center in a circular rather than linear pattern.

7) Click OK and save your photo.

Creating a digital photocopy

1) Open the black & white photo you want to convert to a photocopy.

2) Set the foreground color to black and the background to white.

3) Select **Filter/Sketch/Photocopy**.

4) Adjust the Detail slider to increase or decrease the amount of detail that is to be retained in the final photo.

5) Adjust the Darkness slider to increase or decrease the density of the dark tones of the photo. The greater the Darkness setting, the more contrast there will be in the final photo.

6) Click OK and save your photo.

PHOTOCOPY
The Photoshop photocopy dialog box with the settings used to create the effect opposite.

Lith printing

A darkroom 'lith' print is made using suitable photographic paper processed in lithographic developer. Lith prints are notable for their tonal range of deep shadows to creamy highlights.

Lith printing in the darkroom is a time consuming and fiddly process. The variables involved mean that each print is unique and essentially unrepeatable. Creating a lith print involves overexposing a print by a stop or two. Darkroom prints get darker the longer they are exposed to light, so overexposing a print counter-intuitively means giving it less light. Once the print has been exposed, it is then developed in a lith developer. The colors of a lith print tend to be warm, a mix of chocolates and ivories. Lith prints also tend to be more grainy

than a normal print would be created from the same negative.

The technique described on the opposite page emulates the distinctive look of a lith print. A photo with a good contrast range is recommended. Because the chemical process is so variable (even the age of the developer you use has an effect on the color of the final print), there is ultimately no 'correct' solution. To vary the effect, try altering the hue and saturation values in step 4 and the brightness and contrast in step 8.

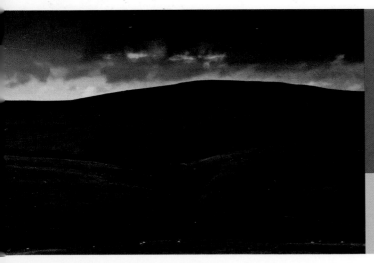

BROODING LANDSCAPE
Dark, stormy landscapes suit the lith print technique. I used a three-stop ND graduate filter in this scene to avoid overexposing the sky, giving me a good range of contrast to work with later in Photoshop.

Canon 7D, 70–200mm lens (at 70mm), 0.5 sec. at f/13, ISO 100

Digital lith printing

1) Open the black & white photo you want to turn into a lith print. Add noise or grain to suit *(see page 104)*.

2) Create a copy of the background layer and rename this new layer 'Lith effect.' Set the blend mode to Multiply.

3) Add a Levels adjustment layer above this new layer. Set the Shadow output level to 30. Click OK.

4) Add a Hue/Saturation adjustment layer above the Levels layer. Select the Colorize option on the Hue/Saturation dialog box, and set both Hue and Saturation to 30. Click OK.

5) Select both adjustment layers by holding down the Shift key and clicking on both layers in turn. Select Create Clipping Mask from the Layers palette menu. This will confine the effect of these two layers to the lith effect layer.

6) Select the original photo layer (this will typically be called Background, unless you've previously changed the name).

7) Add a Brightness/Contrast adjustment layer. Set Brightness to 50 and Contrast to 100.

8) Flatten the photo and save.

RICH AND PEATY
The water of the River Roe in County Derry, Northern Ireland had a creamy, peaty quality that works well as a digital lith print.

Canon 1DS MkII, 17–40mm lens (at 20mm), 6 sec. at f/16, ISO 100, 5 stop ND

Adding a border

You don't need to be satisfied with your photos having perfectly straight edges. Adding a distinctive border can be the finishing touch that gives a sense of style to your photos.

Adding a simple border

1) Open the black & white photo you want to add a border to.

2) Add a selection around the entire photo using **Select/All**.

3) Go back to the Select menu and this time choose **Select/Modify/Border**.

4) Type the size of the border into the dialog box. The higher the number, the thicker the border size.

5) Set the foreground color to the color you want your border to be.

6) Select **Edit/Fill**. Once the Fill dialog box is displayed choose Use Foreground Color from the Contents drop-down menu. Click OK.

7) The selection should now be filled with the foreground color. Choose **Select/Deselect** from the Select menu to remove the selection.

8) Save your photo.

Creating a vignette

1) Open the black & white photo you want to add a vignette to.

2) Choose a foreground color. White or black is generally effective.

3) Add a Gradient adjustment layer. When the dialog box is displayed change the gradient to Foreground to Transparent in the drop-down menu.

4) Change the style to Radial. Set the angle to 90°. Check both Reverse and Align with Layer if not already selected. Finally change the Scaling slider to suit. The smaller the number, the larger the vignette effect.

5) When you are happy with the effect, flatten the image and save your photo.

Adding a ragged paper border

1) Open the black & white photo you want to add a border to. The technique will be more effective with photos that are reasonably dark-toned around the four edges.

2) Add a new layer to the photo. Select **Edit/Fill**. Set the Use drop-down menu to Black and click OK. Set the Blend mode on the layer palette to Screen using the drop-down menu.

3) Set the foreground color to white (R:255, G:255, B:255).

4) Select the brush tool. Set the pixel size to 45, the hardness to 70%, and the flow and opacity to 100%. Draw along the edge of your photo. You don't have to be precise; in fact, the more loose you are the better the effect. As you work, change the size and opacity of the brush to vary the look of the border. The lower the opacity, the softer the edge will be.

5) If you want to refine the shape of the border, set the foreground color to black (R:0, G:0. B:0)

and use your brush to paint over it. Change the foreground color to white when you want to add to the border again.

6) Try to bring the border somewhere between 70 and 100 pixels in from the side. Continue to draw until you have created a white border on all four edges of the photo.

7) Select **Filter/Brush Strokes/Spatter**. Use the sliders to change the Spray Radius and Smoothness of the spatter effect. There are no 'correct' settings, but as a starting point try 25 for the Spray Radius and 10 for the smoothness.

8) When you are happy with the effect, flatten the image and save your photo.

STONE TOWN WINDOW

Canon 5D, 50mm lens, 1/125 sec. at f/7.1, ISO 400

Adding a ragged border around your photo works particularly well if you then print the photo onto a textured fine-art paper *(see page 128).*

CHAPTER 7 SUBJECTS

Choosing your subject

Everyone has their own personal interests that help to define what subjects they like to photograph. Here we explore these themes.

Photographers are often described by the subject they specialize in. Thus we have landscape photographers, portrait photographers, architectural photographers, and so on. However, a creative photographer will be open to working in any genre and using their acquired skill in any situation.

The moral is not to feel too constrained by the division of photography into various subjects. With imagination, subject matter can be mixed and matched. Portraits can be created outside in the landscape just as natural subjects can be photographed in a studio.

The key to producing the best photography you can is partially practice, but also actively seeking out the work of other photographers

interested in similar subjects. Not to copy that work wholesale, but for inspiration and for the sheer pleasure of looking. If you follow a particular photographer over the course of their career, it is always interesting to see how their style develops. Often the early photography is radically different to the later work.

To see a progression in your own photography, consider working on distinct projects with a beginning and an end. Keep your mistakes as well as your successes, and use both to try to objectively appraise your work. Once you feel that you've come to the end of a particular project, do something with the photos, such as arrange an exhibition or produce an album of the work.

FARM GATE
This photo was one of a series I shot along the St Cuthbert's Way, a long-distance path in the Scottish Borders and northern England. The project took a year to complete and eventually became an exhibition.

Canon 5D, 24mm TS-E lens, 1.6 sec. at f/14, ISO 100

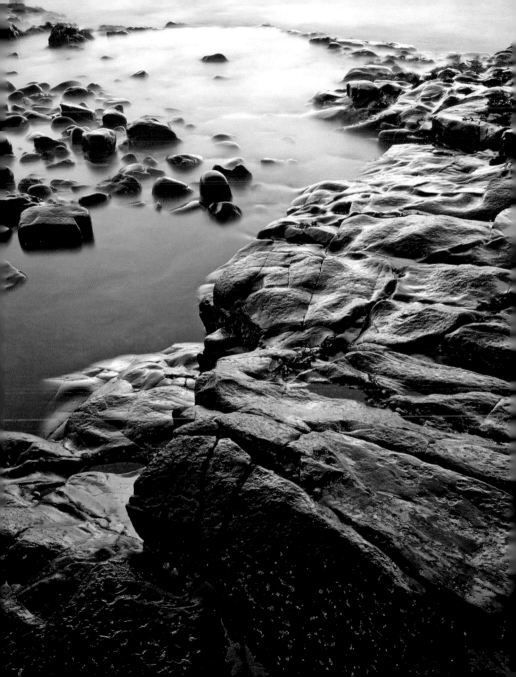

People

As a species, we are strongly inclined to sociability. So it is not surprising that people, from family and friends to the latest glamorous supermodel, are the most popular photographic subject of all.

The art of photographing people is to successfully capture something of their personality. How well you achieve this will depend on your rapport with your subject. Each age group has its own specific challenges.

Children

From toddlers to adolescents, children are generally harder to direct or influence than adults, but are also less guarded and more spontaneous. There is no 'one size fits all' way to get your subject to react how you want. Like adults, some children are immediately at ease with the camera. Others will be less happy and will make their displeasure known quite audibly! Bribery with candy may work, but may not be appreciated by the child's parents. Patience and an entertaining, but not patronizing manner will go a long way to getting the results you want. The important thing is to have fun. If you are not enjoying yourself, why should the child?

There are several possible approaches you can take to the style of the final photo, which will depend on the personality of the child and the wishes of the parent. A soft, high-key *(see page 50)* photo will help to convey a feeling of childlike innocence. A more contrasty, grainier approach will suit the more mischievous child.

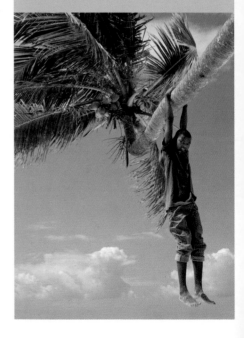

HANGING AROUND
This young boy on the island of Zanzibar was desperate for attention. When he eventually climbed up a palm tree to pose, I framed the photo as simply as possible to avoid anything that would be a distraction to the composition.

Canon 5D, 50mm lens, 1/80 sec. at f/11, ISO 200

Adults

Openness is the key to getting the best out of your adult subject. Discuss with your subject what you will be doing and don't be afraid to ask their opinion of what they would like to see in the final photo. The most frequent comment you will hear is *"I don't like having my photograph taken."* If your subject is nervous, try to reassure them.

Humor is a good way to get people to relax, though you will need to use your judgment on how much is appropriate for the situation. Once the photograph has been created, be prepared to show the result to your subject using the camera's LCD screen. If they don't like it, don't be too offended. Ask them why they feel it hasn't worked and be prepared to try again.

As with children, there are several different approaches you can use for the style of the final photo. A lot will depend on the personality of your subject and how best you can represent it. Although it is a cliché now, a soft-focus effect

was once ubiquitous when photographing women. This was usually achieved through the use of a filter fixed to the lens, though now the same effect can be achieved in Photoshop during post-production *(see page 102)*. Men will probably suit a 'harder' approach, both in terms of the lighting you use and when converting the photo to black & white. Try experimenting with grain and techniques such as lith printing *(see page 134)*.

Using flash

Everyone likes to look their best. The least flattering light you can use is a flash unit attached directly to your camera. Because the light is so direct, it can look harsh and artificial. If it's at all possible, try to bounce the flash light off a convenient ceiling or wall. This will help to create a much softer and more natural looking lighting source. Where flash comes into its own is as a fill-in light to help balance contrast. This is particularly useful when the sun is behind your subject and their face is in shadow.

Canon 5D, 200mm lens,
1/800 sec. at f/2.8, ISO 400

WAITING
Including personal possessions with your subject helps to tell their story. I was taken by the way this man was leaning nonchalantly but proprietarily against his bike. The fact that a cat had settled next to the front wheel was an added bonus!

Canon 5D, 28mm lens,
1/60 sec. at f/10, ISO
200

ACTIVITY

Posing your subject can result in an artificial-looking photo. I knew what I wanted from this shot and allowed my subject time to relax. After a while, she was so absorbed in looking through her binoculars that she forgot about me and I captured a natural-looking photo.

Travel

The creative urge is often lacking in a familiar environment, which is why travel photography and the lure of the exotic has such an appeal. As with portraiture, the key to successful travel photography is capturing the essence of the subject

Planning is essential to get the best out of your travel photography. This has never been easier with internet resources such as Google Earth and Bing complementing the more traditional guidebook. However, be open to your destination throwing a few surprises at you. It's often the unplanned situation that yields the most rewarding photos.

Creating a checklist of things to take on a trip is a good idea. Spend time thinking about what equipment you think you'd need, including things like battery chargers, and if going abroad, plug adapters. If, once on the trip, you discover something missing, make sure it goes onto the checklist for next time.

On location

At an iconic setting, it's all too easy to make a photo that resembles one created by someone else. If possible spend time looking for an angle or approach that you've not seen tried before. Consider all the viewpoints and lens options available to you. This all takes more time than just arriving at a location and shooting the 'standard' views. However, you will find that the results will be worth the extra effort you make.

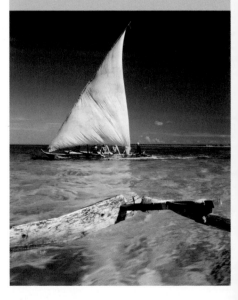

SAILING ON THE INDIAN OCEAN
A dhow is a traditional sailing boat used on the island of Zanzibar. I was fortunate to be on one of two that set out to sea at the same time. I was able to capture the outrigger of my dhow and the other in full sail.

Canon 5D, 28mm lens, 1/100 sec. at f/13, ISO 200

Time of day

The time of day that you're out shooting will make a difference to your photos, too. The light is generally more sympathetic in the early morning or late afternoon. Starting early has the added advantage that popular places are often less busy and so will make the task of finding the 'right' spot easier. In tropical countries, the middle of the day can be too hot to work and this is the ideal time to retire to a cool spot to review your morning's photography.

If you're staying in a city, consider the option of continuing your photography at dusk. Cities and towns are often at their most attractive and romantic in the evening. You will find a tripod becomes a necessity once the light levels drop, as shutter speeds will inevitably increase in length. This is not necessarily a bad thing as, used creatively, long shutter speeds can be a useful way to add atmosphere to your photos.

The human touch

The people you meet on your travels will also make interesting photographic subjects. The key is being friendly and open with the person whose photo you wish to create. Don't be too upset if they refuse; it won't be personal! Thank them politely and move on. Do not be tempted to take a sneaky candid shot when they're not looking. Being able to say "hello," "please," and "thank you" in your subject's language is always appreciated. Once you've created your portrait, be prepared to show the result on your camera's LCD screen.

It's important to think about what you are trying to achieve with your portrait. A simple head and shoulders shot will have immediate impact. However, if you include your subject's surroundings you will go some way to telling the story of that person and give your photo more context.

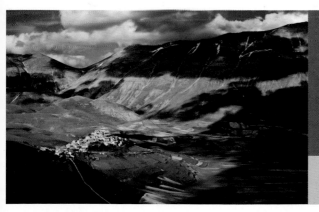

PIANO GRANDE
By choosing a spot high above the village of Castelluccio in the Umbrian region of Italy, I was able to show how small it is in comparison with the mountains that surround it.

Canon 5D, 50mm lens, 100 sec. at f/11, ISO 100

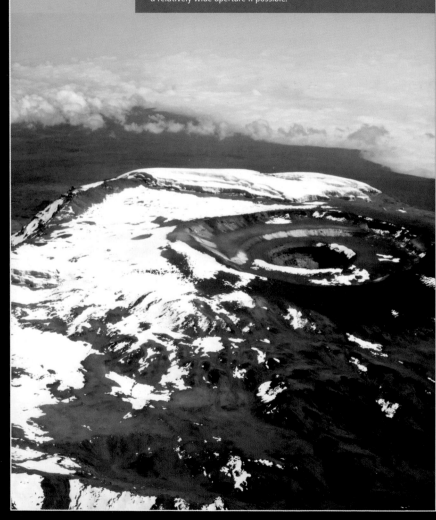

Canon 5D, 50mm lens,
1/1250 sec. at f/7.1,
ISO 100

KILIMANJARO

Be prepared to make photos all through your travels. When flying, request the window seat, particularly if you know that the route takes you over spectacular landscapes. The vibration of the aircraft will affect how steady you can hold your camera, so use a fast shutter speed with a relatively wide aperture if possible.

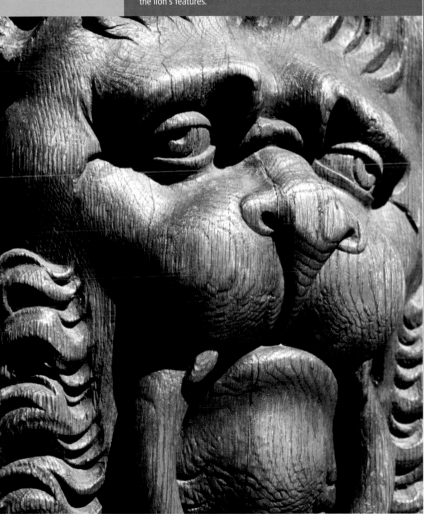

NOBLE LION

Photography can be challenging in the middle of the day when the sun is at its strongest and contrast levels are high. These conditions, however, can be just right for graphic subjects such as this carved doorknocker in Prague, Czech Republic. The deep shadows help to define the shape of the lion's features.

Minolta 9, scanned film, exposure details unrecorded

Landscape

Successful landscape photography depends on the quality of light. This is affected by many factors, and an understanding of these variables will help to improve your photos.

The seasons

Away from the tropics, the length of the day will vary from season to season. During the winter months, the sun will rise later and set sooner the closer to the poles you travel. The winter solstice (December 21 in the northern hemisphere, June 21 in the southern) marks the shortest day of the year. As well as the day shortening, the sun does not rise as high in the sky during winter as during the summer. In fact, within the Arctic and Antarctic Circles, the sun does not rise above the

horizon at all around the period of the winter solstice.

In many ways, winter is the ideal time for black & white photography. Because the sun is always low, the light is generally more sympathetic throughout the day. Even at noon, shadows are relatively long and help to add character to a landscape.

In summer, the opposite is true. Night is curtailed and the sun rises higher in the sky during the day than in winter. At noon, the sun is at its highest and to all intents and purposes is directly overhead. This makes for short, dark shadows that aren't particularly attractive and can cause problems with contrast.

The summer solstice (June 21 in the northern hemisphere, December 21 in the southern) marks the longest day of the year. In the Arctic

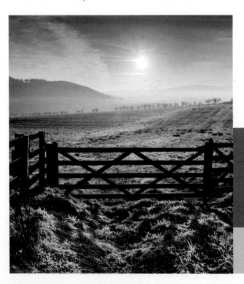

INTRIGUING SHADOWS
In winter, at a latitude of 55° North, the sun is sufficiently low in the sky even in the early afternoon to create interesting shadows in the textures on the ground.

Canon 1DS MkII, 17–40mm lens (at 36mm), 1/30 sec. at f/11, ISO 100

and Antarctic Circles at the summer solstice, the sun does not set below the horizon, a phenomenon known as the Midnight Sun.

Weather

Although the seasons change gradually, weather can vary from hour to hour. The earth's atmosphere is a chaotic system and weather forecasting is less reliable the farther into the future it is projected. As a landscape photographer, it pays to be aware of what the weather will do when you're outside, though of course nothing can be guaranteed.

It is air pressure that causes weather. Low air pressure is caused by air rising. As the air rises, it begins to expand and cool. Cold air is bad at retaining water and so will lead to the formation of clouds and eventually rain. High air pressure is caused by air falling. As the air falls, it becomes more dense and begins to warm up. Warmer air is able to retain water more effectively, so there is more chance of clear blue skies and fair weather.

Good weather isn't necessarily good news when it comes to creating interesting photos. If a high-pressure system sits over a geographical area for several days, dust and smog can build up. This will create haze that will adversely affect visibility. Bad weather, on the other hand, is often more dramatic and changeable with the potential for more interesting photography.

Why not try...?

Learning about different cloud types and how they can help you to predict the vagaries of the weather.

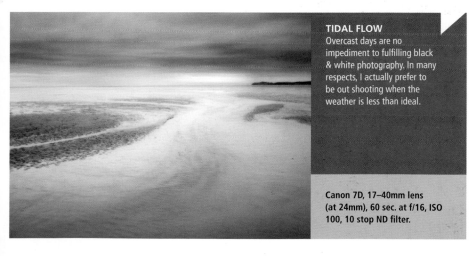

TIDAL FLOW
Overcast days are no impediment to fulfilling black & white photography. In many respects, I actually prefer to be out shooting when the weather is less than ideal.

Canon 7D, 17–40mm lens (at 24mm), 60 sec. at f/16, ISO 100, 10 stop ND filter.

Canon 7D, 17–40mm
lens (at 40mm), 1/80 sec.
at f/5.6, ISO 100

Some subjects suit soft light, but these leaves benefited from strong
sunlight shining through them. I metered from the brightest leaf to
establish the correct exposure. If I'd used the darker background as the
basis for my exposure, the photo would have been overexposed *(see
page 45)*.

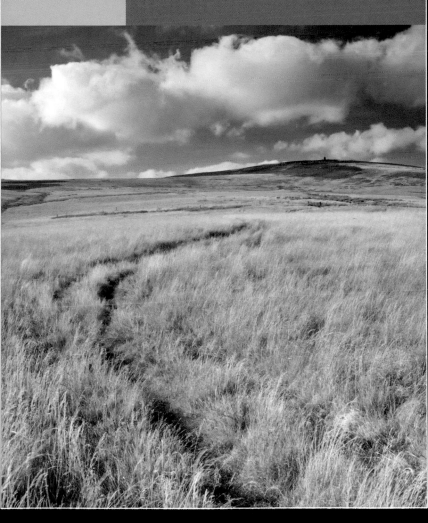

Canon 5D, 50mm lens,
1/8 sec. at f/14, ISO 100

PADON HILL
Open grassland is often featureless and it is sometimes
a problem to find an interesting foreground. Out in the
Northumberland, United Kingdom countryside, I was lucky to
stumble on a track through the grass that visually leads the
eye up to the cairn on the hill's summit.

Social and events photography

To succeed at social and events photography, you often need to be able to think on your feet. However, it is possible to make your life easier by careful preparation before you start.

Preparation

If the event has an itinerary, make sure you have a copy and that you arrive long before the start. Use this time to familiarize yourself with your location. If the event is spread over some distance, make sure you know the shortest routes around the area.

A zoom lens with a good range of focal lengths is an invaluable part of your kit. Time spent changing lenses is time enough to miss something crucial happening. That said, a prime lens with a wide maximum aperture

(see page 38) will be worth its weight in gold for low-light situations where flash is not considered appropriate.

If you are working to a commission, try to think through all the possibilities that the event is likely to throw at you, both good and bad. Carry spare batteries and even a second camera body if possible. If you have a willing partner, bring him or her along, too: they may not be able to help with the actual photography, but will be a valuable asset in dealing with other practical details.

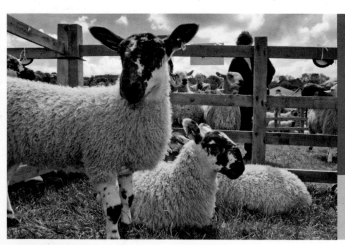

SHEEP PEN
Agricultural shows offer a wealth of photographic opportunities, from the exhibitors to their prize livestock. For this photo, I crouched down to the eye-level of these sheep to get their perspective on events.

Canon 7D, 17–40mm lens (at 17mm), 1/60 sec. at f/16, ISO 320

Weddings

A wedding wouldn't be the same without someone creating a photographic record. The timeless quality of black & white photography is the ideal medium for this life-changing event. If you have been asked by the couple to be the main photographer, you will first need to discuss with them what their wishes are. Some couples will not be sure whether they want color or black & white. The beauty of digital photography is that it is possible to produce both from the same files.

It is important to work out a shot list for the day. Again, this would be done in conjunction with the couple. Keep this list to hand and make sure you work your way through it methodically, checking off the shots as you go along.

As well as the standard family shots, look for potential candid opportunities. When people are unaware of, or are used to the presence of, a camera they will tend to be more relaxed and natural. It is often the candid shots that best represent the atmosphere of the day.

Look out for details, too. Weddings are rich with detail from rings on fingers to flowers and food. This often involves getting in close, so be prepared to be forward but always polite. You may get some odd looks at times, but you'll find the results worth it.

Finally, don't forget to enjoy yourself on the day.

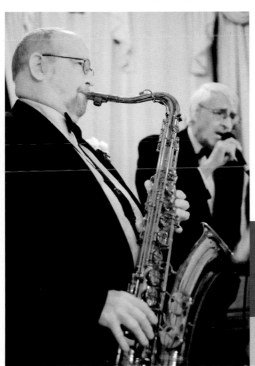

WEDDING MUSIC
The couple who asked me to take photos at their wedding were both keen on music. Therefore, shots of the band at the reception were a must and went onto the shot list for the day.

Canon 5D, 50mm lens, 1/40 sec. at f/2.2, ISO 1600

Minolta 9, scanned
film, exposure details
unrecorded

I established beforehand who was in charge of this group of soldiers
during a recreation of a historical battle. I knew that everyone would
look in the direction of whoever gave the orders, so I was able to find
a position to make the most of the compositional opportunities this
knowledge would help to create.

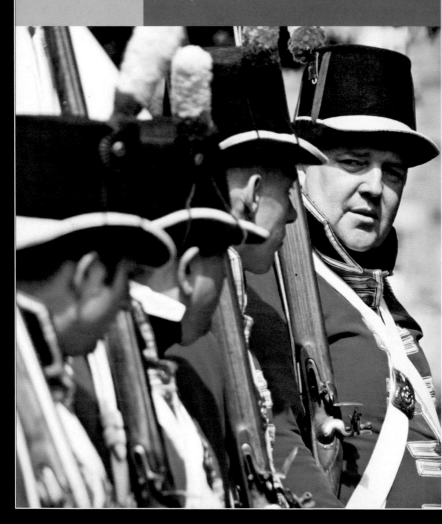

Canon 1DS MkII,
17–40mm lens (at
21mm), 1/13 sec. at f/4,
ISO 800

SETTING UP

The preparations that happen before an event are often as fascinating as the event itself. This is another good reason to arrive in plenty of time to familiarize yourself with the forthcoming activities. I caught this street performer in a pool of light as he got himself ready for an evening festival in a Northumbrian park.

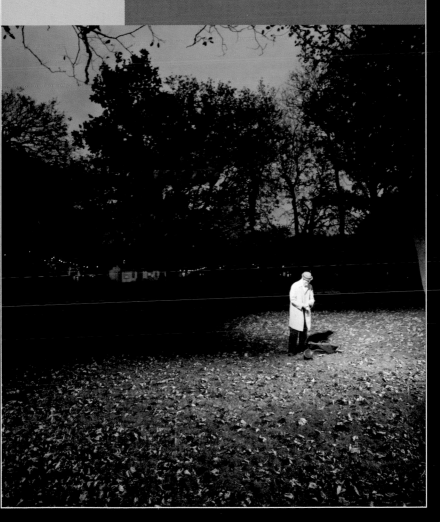

Architecture

Buildings come in all shapes, sizes, and styles. This variety offers a wealth of interesting photographic opportunities.

Time of Day

Like landscapes, architecture benefits from sympathetic light. Using a map and compass will help you determine at what times of day which sides of your subject will be lit. The type of light that is suitable will depend on your subject.

Modern buildings often benefit from hard light with deep shadows as the contrast helps to emphasize the shape and construction of the structure. Buildings with glass facades can be a problem if the sun is shining directly onto them. Using a polarizer can help to cut down some of this glare, but only if your camera is at an angle of approximately 35° to the glass surface.

If a building is floodlit, shooting it at night is an effective way to add atmosphere to your photos. The key to this style of photography is to shoot when there is still light in the sky so that the shape of your subject isn't lost against a black background. Half an hour or so after sunset is generally about right, though it pays to be set up long before then. Because light levels will be so low by this point of the evening, you will need to use a tripod or other steady support.

Large and small

There is no one right approach to architectural photography. You must decide what story you want to tell. Including the area around a building will show it in context to its neighbors. However, don't just consider the bigger picture.

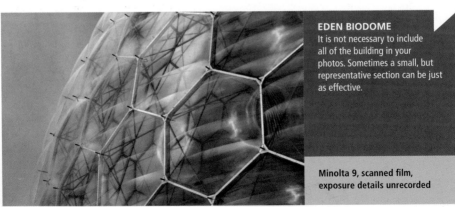

EDEN BIODOME
It is not necessary to include all of the building in your photos. Sometimes a small, but representative section can be just as effective.

Minolta 9, scanned film, exposure details unrecorded

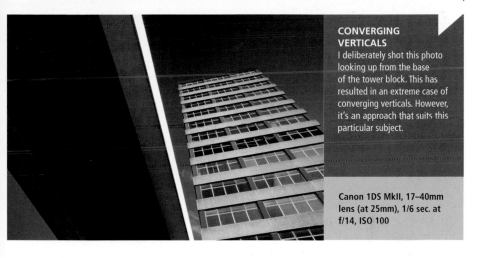

Buildings, particularly older structures, are often rich in small details. A long lens will help you frame these details, especially if they are above head height.

Lens choice

Buildings tend to be very geometric. The wider the lens that you use, the more chance that distortion will be added to the photo. Straight lines quickly cease to be straight—which generally isn't the effect the architect was striving for. Whenever possible, use the longest lens you can without needing to tip the camera back from a vertical position.

If your camera isn't parallel to the building, you will introduce an effect known as converging verticals. This will give the impression that the building is leaning backwards. However, deliberately breaking the rules can be very effective. It's all a matter of degree. Too little can look like a mistake, while being bold can be said to be a matter of personal style.

People and buildings

Ultimately a building will be used by people, and so it makes sense to create photos that have the human touch. A person in an architectural photo has the benefit of helping to convey the scale of a building. However, there are times when it is not desirable to include people. This may be difficult to achieve, particularly in a busy environment. One solution is to arrive early in the morning before anyone is around. However, this is less effective in winter when the days are shorter. Another solution is to use an ND filter *(see page 33)* to slow the shutter speed down to several seconds or more. Anyone who moves during that time period will vanish from the photo entirely.

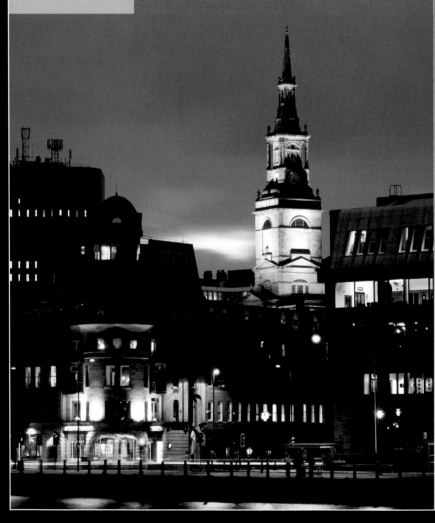

EVENING LIGHTS

Cities at night make interesting subjects for black & white photography. This image is all about light and dark. The lit areas of the buildings help to give shape and contrast to the dark shadows. This photo was taken about half an hour after sunset when there was still light in the sky, avoiding the outlines of the buildings being lost against pure black.

Pentax 67II, scanned film, exposure details unrecorded

Canon 1DS MkII, 24mm
TS-E lens, 1/125 sec. at
f/5.6, ISO 100

DIFFERENT APPROACHES

Architectural photographers use 'tilt and shift' lenses that allow them to
shift the lens up, down, left, or right, or tilt forward or backward. For this
photo, I tilted the lens axis forward, which has had the effect of throwing
the top and the bottom of the picture out of focus. I thought this odd
visual effect added to the unearthly quality of the foreground gravestone.

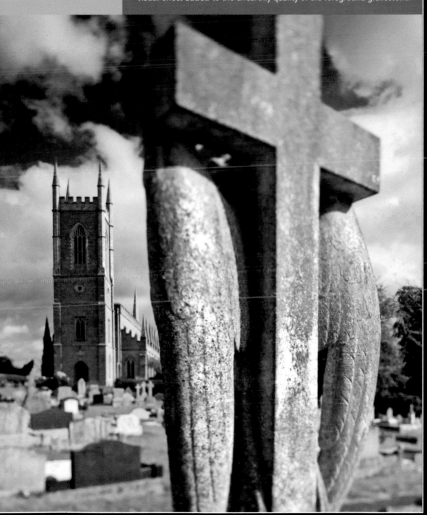

Still Life

You don't need an elaborate studio setup to create pleasing still life photos. A flat surface, a subject, and some imagination are all you need.

Composition

It is all too easy to make a still life setup look contrived. If you are just beginning to experiment with still life, it pays to think small initially. Use one object as your subject and try different lighting setups and backgrounds. Once you feel confident to try a more complex setup, think about what subjects will go well together.

A theme that runs through the subjects of your still life composition will be more effective than a random collection of objects. The size and shape of your subjects will determine how they should be arranged. Generally, smaller objects should be at the front, larger objects behind. However, like all rules in photography this can be broken for effect. A contrast of different textures can be appealing: hard and soft, smooth and rough, shiny and matt.

Lighting

The simplest lighting setup is natural light coming through a window. If the light is direct, it can cause a problem with contrast. A white board on the opposite side of your subject to the source of the light will help to balance the contrast by reflecting light back into the shadows. Just be certain that the board isn't in the shot unless you are prepared to do more post-processing than intended.

A certain amount of contrast is desirable, since this will help to define the shape and form of your subject. Side lighting will help to emphasize the texture of your subject, whereas frontal lighting will flatten texture and shape. Lighting your subject from behind will make the subject silhouetted; the shape will be defined by any light that shines around the edge of it.

HAMMER
I kept the lighting deliberately simple for this shot. I used a lamp pointing up toward the head of the hammer. This was the most important part of the photo, so I made sure I focused there too and used a large aperture to throw the rest of the scene out of focus.

Canon 1DS MkII, 100mm lens, 1.3 sec. at f/4.5, ISO 50

Background

What is behind your subject will need to be considered carefully. A background that is too busy will distract from your subject. This includes unwanted wrinkles if you are using fabric as your backdrop. Ten minutes with an iron is better than several hours' correction with Photoshop. Using selective focusing *(see page 70)* and throwing the background out of focus will help, though you will need to be careful of your technique if you have multiple subjects at different distances to the camera.

A plain white or black background is effective, but you will need to ensure that the final exposure is not affected. Using the spot meter on your camera and metering from your subject is one way to avoid this. If you use a colored background, choose a color that is very different to your subject. This will make it easier during the black & white conversion process to separate the two tonally.

Final checks

Unless your subject is old and battered, it pays to check for dust and fingerprints before you shoot. Glass is particularly prone to picking up grease marks during handling, so it's worth wearing gloves when setting up your composition. Use a small brush or blower to clean dust from your subject. Check that the aperture you use is sufficient to create the depth of field you need to get all your subject sharp. Depth of field decreases the closer the focus point is to the front of the lens. Subjects that are small will require you to get in close, which can make sharpness problematic. If your camera has depth of field preview, use this to check sharpness. Focus precisely on the most important part of your subject, the point at which you want critical sharpness. Switch to manual focus if necessary.

JUMPING FOR JOY
I used white cardboard as the background for this artist's mannequin to show the shadow clearly. If I'd used a dark background the shadow would have been lost and the photo would not have had a three-dimensional quality.

Canon 5D, 100mm lens, 1/16 sec. at f/16, ISO 100

Canon G10, lens at
6.1mm, 0.5 sec. at
f/5.0, ISO 80

EXHIBITS

Still life doesn't need to be set up specially by you. Museums offer a range of ready-made still life possibilities. Not all museums allow photography, so it is important to check before arranging a visit. If the exhibits are behind glass, try to get as close to the glass as possible to avoid unwanted reflections.

Canon 5D, 50mm lens,
1/60 sec. at f/2.5,
ISO 1250

I spotted this collection of Ancient Egyptian god figurines in a junk shop in Luxor. Because the shop was dimly lit and I didn't have a tripod, I needed to use a wide aperture to maintain a reasonable shutter speed even with a high ISO. This meant I had very little depth of field, so my focusing had to be very precise.

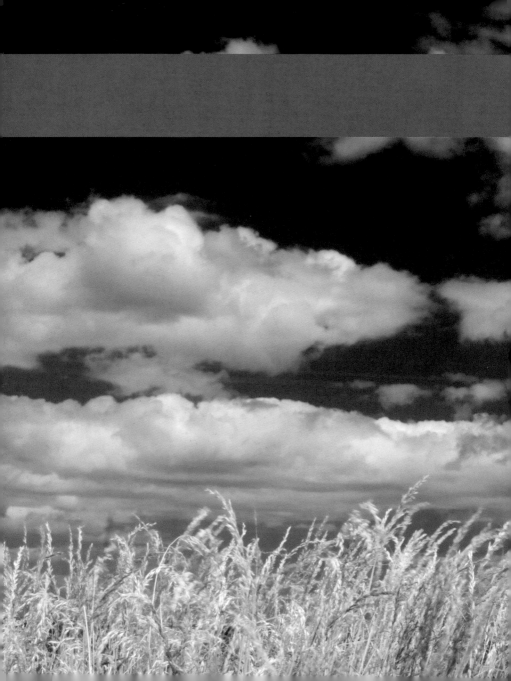

CHAPTER 8 PRINTING

Inkjet Printers

There is a bewildering choice of inkjet printers on the market today, with new models announced regularly. Chosen wisely, a printer will last for years. The key is to know what you want before buying.

An inkjet printer creates an image by firing small droplets of ink at paper. When a print is created, the paper is pulled through the printer in precise, regular steps. During this process, a head containing the ink cartridges and the ink delivery system scans back and forth, laying down the ink as it does so. Different manufacturers use different methods to achieve this, though the results are broadly similar.

There are two different types of inks used in domestic inkjet printers: dye and pigment. Ultraviolet light affects all photographic media, resulting in images losing color and contrast over time. Dye-based inks are usually inexpensive, but are prone to this type of fading.

Pigment-based inks are more archival, but are also more expensive. No matter what type of ink your printer uses, it is advisable to keep prints out of direct sunlight to minimize fading.

All inkjet printers use ink cartridges. The most basic setup is a system that uses four cartridges: one black, one cyan, one yellow, and one magenta. By combining these four colors in varying amounts, an inkjet printer can produce an extremely wide range of colors, sufficient to produce a photo-quality image. High-end inkjet printers increase the range of possible colors available by using lighter versions of the inks above. These printers use up to nine cartridges; three blacks of varying density, and a normal and light version of cyan, yellow, and magenta.

CANON PIXMA IX7000
A six-cartridge A3+ inkjet printer from Canon, one of the leading printer manufacturers.

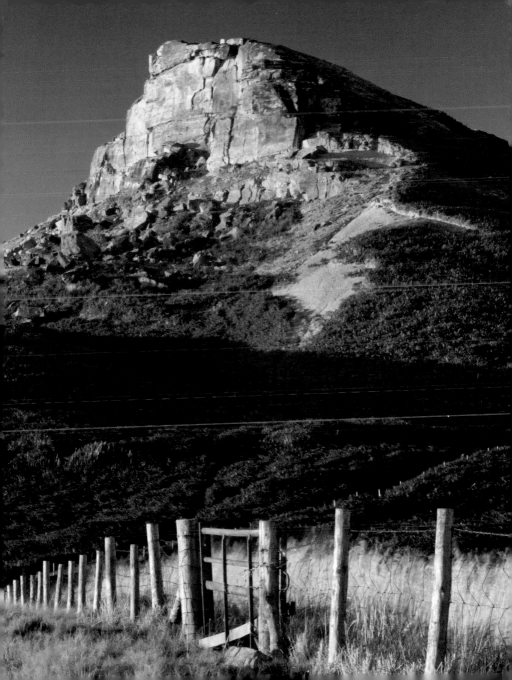

How to buy an inkjet printer

If you are considering the purchase of a printer, you should ask yourself what specification and features you really need.

Can I afford the replacement cartridges?

Buying an inkjet printer is only the start of the costs you will incur. Replacing a full set of ink cartridges can be expensive. However, depending on what you regularly print, you will find that some cartridges are used more quickly than others, so it is rare to need to replace everything in one go.

Check the cost of cartridges for a particular printer before you buy it and look for the manufacturer's fact sheet. This should give you some idea of the printer's potential ink usage. Avoid printers that only have one cartridge for all the colors. You will find that once one color is depleted, you will need to replace the lot, even if the other colors are still usable.

What image quality should I expect?

The resolution of a printer is measured in dots per inch (dpi). This is the number of individual spots of ink that are laid down across an inch of paper. The different inks in the printer are mixed in varying proportions to simulate the full range of colors in the original photo.

Printers are capable of printing at different resolutions up to their maximum dpi. The higher the dpi of the printer, the more dots of color it can use for every pixel in the photo, and the better the tonal gradations on the print. The downside of this is that printing time and ink usage increase the higher the dpi is set.

How fast is the printer?

Printing a full-quality photo will never be instant, but some printers manage it more quickly than others. The printer specifications should tell you what the typical print speed is and will be measured in pages per minute. Don't dismiss printers that seem relatively slow, however, since sometimes quality is sacrificed for speed and vice versa. If you regularly print large numbers of photos, speed will be important. If you only use your printer occasionally, the waiting time may not be as onerous as you think if it results in the best possible reproduction of your photo.

How big do I want to print?

Printers come in all shapes and sizes. Generally, the bigger the printer, the higher the cost. If you only ever intend to print letter-sized (A4) prints, then a printer capable of printing larger than this is a waste of money and desk space. If you do occasionally want to print larger photos, investigate the cost of a professional photo lab printing them for you. Rather than buying a large printer, the price differential over time, once you've included ink and paper costs, can often be in the lab's favor.

Do I need Pictbridge?

Not all printers need to connect to a PC to be able to print photos. The Pictbridge standard allows photos to be printed directly from a digital camera via a USB cable. The printing of the photos is controlled through the camera's menu system, though one limitation is that typically only JPEG files can be printed.

Some printers also have a memory card slot, so that photos from a camera can be accessed that way. You would usually only print photos that have not been through post-production directly from your camera. As a black & white

photographer, the lack of Pictbridge on a printer should not be considered a deal breaker, though it is useful for printing 'snaps.'

What else do I need to think about?

The warranty period of printers varies between manufacturers. If you expect your printer to be used heavily, one with a longer warranty will be worth considering. Check what the warranty covers and what the typical repair costs will be once the warranty expires.

Continuous ink systems

As previously mentioned, keeping your printer supplied with ink can be expensive. The most economical solution is to use a continuous ink system (CIS), manufactured by a third party—printer manufacturers don't supply CIS products. In these systems, ink is fed through flexible plastic tubes from large bottles into modified replacement cartridges in your printer. Because you are buying ink in bulk, the savings can be dramatic. Lyson is a major producer of CIS products, though there are now many different systems to choose from.

There are a few drawbacks to using CIS. Because you are essentially modifying your printer, your warranty will be voided. It is, therefore, not advisable to use a CIS product in the first year of printer ownership.

Another drawback is that you will need new profiles for the paper you use, since the inks will differ slightly from those of the printer manufacturer. Profiles for popular papers will generally be available from the website of the CIS manufacturer, but anything esoteric will require the creation of your own profile. Manufacturers such as Lyson usually also produce their own range of papers and will supply profiles free of charge for these products.

The final drawback is that not every printer has a relevant CIS product. The most popular printers by Epson, Canon, and HP are usually supported, although there will be a delay before CIS for the most up-to-date printers are released.

Preparing to Print

Profiles

One of the biggest disappointments when printing is to see a big difference between the photo onscreen and on paper. Every digital imaging device (cameras, monitors, printers, etc.) has a different color gamut. This is the range of colors the device can successfully reproduce. Your printer will not be able to reproduce all the colors on your monitor and vice versa.

To make matters more complicated still, the type of paper you use will also affect how colors are reproduced on your prints. Different types of paper absorb the inks in different ways. Matte paper, for example, is far more absorbent than gloss.

Photoshop uses information files known as ICC profiles to help translate the color characteristics of one device when used with another. If you have calibrated your monitor,

then Photoshop will know exactly how your monitor displays colors, because it will have an associated profile.

You will also need a profile of the paper that you want to use with your printer. When you print an image, Photoshop compares the two profiles and modifies the printing process so that the colors on the print will be as close to those on the monitor as possible.

If you use paper by the same manufacturer as your printer, you will usually find the correct paper profiles were added when the printer drivers were installed. If they are not already there, they are usually readily available for download from the manufacturer's web site. Third-party paper producers also often produce profiles for popular printers. If no profiles are available, you can have them made for specific printer/paper combinations by a specialist, or invest in a printer profiler device.

Installing profiles

If you have downloaded or created a paper profile, it must be installed so that Photoshop knows where to look for it.

MAC OS X
Move the profile to **Library/ColorSync/Profles**.

Windows XP/Vista/7
Right-click on the profile and select Install Profile from the popup menu. Alternatively, move the profile to **Windows/System32/Spool/Drivers/Color**.

Printing from Photoshop

The key to successful printing using Photoshop is to let the application manage the process from start to finish. To do this, the various print dialog boxes must be carefully set a certain way.

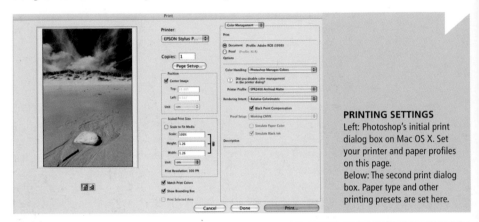

PRINTING SETTINGS
Left: Photoshop's initial print dialog box on Mac OS X. Set your printer and paper profiles on this page.
Below: The second print dialog box. Paper type and other printing presets are set here.

1) Go to **File/Print**. Select Photoshop Manages Colors, then choose the correct printer and paper profile from the Printer Profile menu. If not already set, select Perceptual as the Rendering Intent and check Black Point Compensation. Click on Print to proceed to the next stage.

2) If you are using an Epson printer, select Off on the Color Management option. If you are using a Mac and a non-Epson printer, look for a color management option that can be set to Off or to ColorSync. On Windows, look for a color management setting that can be set to ICM, Off, or Non.

3) Set the paper type recommended for the paper you are about to print with. Select Print to make the final print.

Image resolution

The resolution of a photo is defined by the number of pixels used to create the photo. The more pixels it has, the higher the resolution of the photo.

The standard for printing photo-quality images is 300 pixels per inch (or ppi). If your photo is 3000 pixels wide, this will create a print 10in (25cm) across at 300ppi (3000/300 ppi = 10in/25cm). Without changing the number of pixels in your photo, you could set the ppi to 150. This will create a print 20in (50cm) across (3000/150ppi = 20in/50cm). However, the quality of the print will be lower, since the same number of pixels are now spread over twice the distance. At 75ppi, the print will be 40in (100cm) across with a still greater loss of quality.

Although this may seem like a drawback, bear in mind that the larger the print, the farther back you will need to stand to look at it. It is possible to use a low ppi value and still produce an acceptable print at a normal viewing distance, even if closer examination reveals flaws.

To change the ppi and print size of your photo, select Image/Image Size. Uncheck Resample Image and change the Resolution value (this is the print resolution you are altering rather than the camera resolution). As you do so, you will see that the Pixel Dimensions do not change, but the Document Size does. The document size is the size that the photo will be when you print it out at the chosen ppi.

ROOFTOP
The photo on the left is set to 300ppi. The photo on the right was set to 15ppi. This has resulted in a much larger print (of which only a very small section has been shown here) at the expense of image quality.

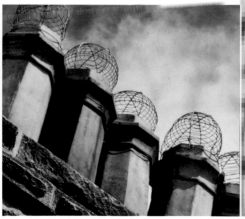

Resizing an image

The Image Size dialog box also allows you to alter the resolution of your photo. In this way, you can specify the dimensions of your photo in inches (or centimeters) without needing to alter the ppi value. To change the resolution of your photo, open up Image Size again. This time leave Resample Image checked. Change either the width or the height of your photo in the Document Size section.

If the dimension value you choose is less than the one there originally, you will see the Pixel Dimensions values decrease. When you click OK, Photoshop resamples your photo, merging pixels as it shrinks it to the desired print size at the specified ppi.

If you choose a dimension value greater than the original, Photoshop will add pixels to your image in a process known as interpolation. Photoshop is essentially making an educated guess on what is needed to fill the gaps when it increases the size of your photo. It is surprising how large a digital photo can be resized without too much loss of quality, though again flaws will be apparent the closer you look at the resulting print.

Once you've altered the document size, you can, of course, change the ppi value to suit. However, it would make little sense to halve the pixel dimensions of your photo, then halve the ppi value, since this would produce a print of the same size as the original with a big drop in quality.

IMAGE SIZE
The Photoshop Image Size dialog box. The photo is from an 18mp camera. At 300ppi, the maximum print size without resizing is nearly 16.94 x 11.27in (43.02 x 28.62cm).

Sharpening

Unless sharpening has been applied in-camera, digital photos can look slightly soft. This softness will make your final print look slightly woolly and not achieve the impact it could.

Sharpening is a slight misnomer for the technique used to 'sharpen' a photo. When a photo is sharpened, contrast is raised between the edges of neighboring pixels in the photo. This increases the apparent acutance of the photo, which, due to how human vision works, appears to raise the overall sharpness.

However, apply too much sharpening and the increase in edge contrast will add ugly halos around the subjects in the photo. Another problem with applying sharpness is that some areas of your photo may require less sharpening than other areas. Skin tone and skies are two good examples of subjects that benefit from minimal sharpening. If your photo is grainy, sharpening will also increase how noticeable the grain is.

Sharpening should also be the last adjustment you make to your photo before printing. If you sharpen, then increase the size of your photo, you will also make any sharpening artifacts more visible.

NOTE

There is no sharpening applied in-camera to a RAW file, though your RAW converter may apply some sharpening on import. Fortunately, this is usually easily turned off on the converter dialog box. By default, JPEGS are usually sharpened automatically in-camera. Your camera should have an option to control how much or how little the JPEGs are sharpened. If you want full control of sharpening using the technique described here, turn off or reduce sharpening in-camera to a minimum.

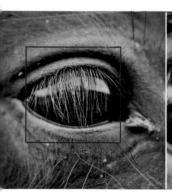
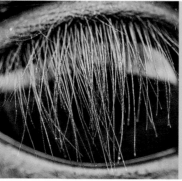

SHARPENED
This photo of a horse's eye has had too much sharpening applied. It is particularly noticeable around the eyelashes, which now have a thin black line around them.

Smart Sharpen

There are many ways to sharpen an image using Photoshop. The most useful of the sharpen filters is Smart Sharpen. Using it will help you avoid the problems mentioned on the previous page.

1) Open the photo you want to sharpen. Zoom into your photo to 100%. This will help you see the effect the filter will have on individual pixels. Select **Filters/Smart Sharpen**.

2) Adjust the Amount slider to alter the degree of sharpening. A larger value will increase the edge contrast of the pixels and so make the photo appear sharper. Use the Radius slider to alter how many pixels surrounding the edge pixels are affected by sharpening. The larger the radius value, the more obvious sharpening becomes.

3) Remove determines how Photoshop sharpens

the photo. Lens Blur finds the details in your photo and sharpens them, reducing the effect of sharpening halos. You can use higher settings of Amount and Radius than you can with the default setting, Gaussian Blur, without oversharpening your photo. The other option, Motion Blur, attempts to reduce the blur caused by camera shake or movement during exposure. Set the Angle value to approximately the direction of movement in your photo when using the Motion Blur setting.

4) Check More Accurate to allow Photoshop to increase the accuracy of the sharpening effect, though this will increase the time taken to process the photo.

5) If you click the Advanced button, you can fine-tune how the highlights and shadows in your photo are sharpened.

6) Click OK to apply sharpening.

SMART SHARPEN
My default setup when using the Smart Sharpen filter

Soft proofing

Printing can be an expensive business, particularly if it takes a few attempts to get it right. Using soft proofing in Photoshop can help to take some of the guesswork out of the process. Soft proofing forces Photoshop to display your photo as it would look when printed out on a particular paper.

To use soft proofing, you will need the profile of the paper you intend to print with installed on your computer *(see page 173)*.

1) Open the photo you want to print.

2) Select **View/Proof Setup/Custom**.

3) Click on the Device to Simulate drop-down menu and choose the correct paper profile from the list. Leave Rendering Intent set to the default and check both Black Point Compensation and Simulate Paper Color. If you want to save these settings, click

on Save and use an easily remembered name for the setting. Click on OK.

4) Your photo will now look a lot flatter. This is because paper does not have the dynamic range of your monitor and there is a difference between the color gamut of the two media.

5) Select **View/Gamut Warning**. Any colors that cannot be reproduced by your printer will be grayed out. Use the adjustment controls, such as Curves, to alter your photo so that there are no areas where the gamut warning shows. Toggle the gamut warning using SHIFT, CTRL (PC) or SHIFT, CMD (Mac) Y to see the changes more easily.

6) Turn off Proof Color by pressing CTRL (PC) or CMD (Mac) Y.

SIMULATING PAPER TYPES
The Photoshop Soft Proofing dialog box, set here to simulate Epson matte paper.

Inkjet paper

There is a bewildering array of different paper types that can be used with inkjet printers. Many people stick with the same brand as their printer. However, like much about photography, experimentation can open up a whole new world of creativity.

Weight

The density, and therefore often the quality, of paper is defined by its weight measured in grams per square meter (shown as gsm or g/m²). The heavier a paper, the more dense it is. A typical sheet of office paper is about 80gsm. When printing photos, ink is laid down thickly by the printer. A paper with a low weight will very quickly become saturated, with the potential for wrinkling or tearing. Paper suitable for printing photos requires a weight of 120gsm or more.

NOTE
Many paper manufacturers sell sample packs of their products. These are a good way to try out and experiment with different papers without committing to buying one type only.

Photographic paper

As well as weight, photographic paper is often measured in terms of opacity and brightness. Opacity is only important if you intend to print on both sides of the paper, since this is a measure of how 'see through' the paper is. Brightness is a measure of how white a paper is on a scale of 1 to 100. Photo paper is typically in the 90s, the brightness achieved by bleaching or by the addition of optical brighteners.

Paper can also be thought to be 'warm,' 'neutral,' or 'cool'. Though the effect will be subtle, the tone of a paper will affect how your photos are perceived. This warmth, or otherwise, of a paper will be particularly noticeable in the highlight areas of your prints. Detailed reviews of photo papers often mention this aspect of their character, which is useful information if you want to refine your black & white prints still further.

Coated papers

Paper suitable for printing photos on has usually been coated to stop the spread of ink as it is applied to the paper. With some gloss papers, this can increase the drying time considerably. The coating is often refined clay. Because of the way the dye and pigment printers work, it is generally not recommended to use paper designed for one system with the printer of another.

Gloss paper

Gloss is the commonly used paper type when printing photos, since it most closely resembles the look and texture of a traditional photo print. Gloss paper is generally smooth to the touch and, because of the way it handles ink, is suitable for photos with a wide contrast range and color vibrancy. The shadow areas of your photo will appear more dense and 'black' than if printed on matte paper.

Semi-gloss, silk, luster, or pearl paper

These papers appear duller than gloss, since they reflect less light and so exhibit less 'glare.' They are a good compromise between the two extremes of gloss and matte papers. Colors are typically less vibrant than if printed on gloss paper, though the color and contrast is still greater than with a matte paper.

Matte paper

The color gamut and contrast of matte papers are typically smaller than those of gloss. A matte print can, therefore, look flatter in comparison with a similar gloss print. It can also look less detailed than a gloss print. As ink is absorbed into the paper more, each ink droplet spreads farther, softening fine detail. Where matte papers have the advantage is in the range of different textures available. Matte papers can be as smooth as gloss or as textured as watercolor paper. This makes them suitable for a more artistic approach to your printing.

Canon 1DS MkII,
50mm lens, 1/100 sec.
at f/9, ISO 200

TOWN LIFE

Beamish Open Air Museum in the northeast of England is a
recreation of an early 20th-century County Durham town. I was
attracted to this view of the bank building and the way the tram
power cables could be used to frame the chimney on the left. After
conversion to black & white, I applied a faint sepia tone to the
photo to help enhance the quaintness of the scene.

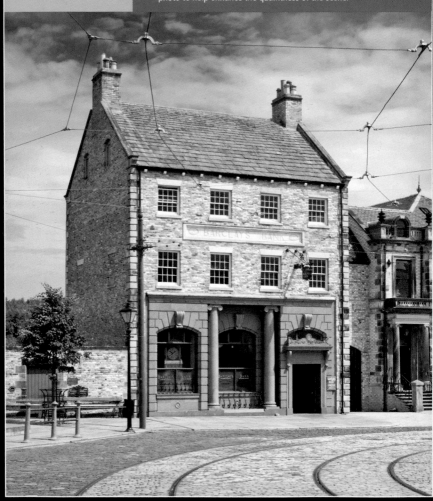

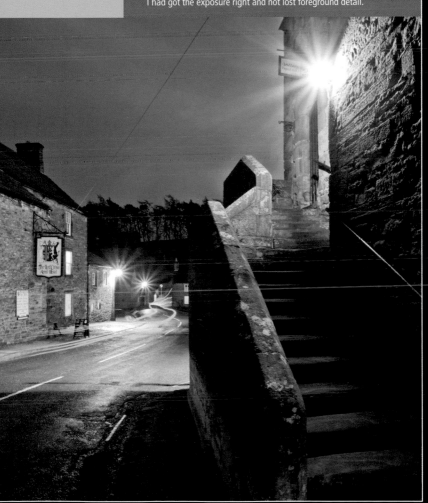

Canon 1DS MkII, 17–40mm lens (at 22mm), 2 min. at f/14, ISO 200

VILLAGE LIFE
Blanchland in Northumberland may look as timeless as Beamish Museum, but is in fact a popular, bustling village. This photo was created at dusk. There was no light on the left side of the staircase, so I used a flashgun off-camera, firing several blips into the shadow during the exposure. The histogram proved useful to check whether I had got the exposure right and not lost foreground detail.

Canon 5D, 50mm lens,
1/100 sec. at f/2.8,
ISO 500

Museums are wonderful places to find unusual juxtapositions of
subjects. The combination of this painting and marble bust attracted my
attention in the Ashmolean Museum, Oxford, United Kingdom. Who was
watching whom? The dim light meant using a large aperture, so I made
sure that the bust was in focus.

Canon 5D, 100mm lens,
1/160 sec. at f/5.0,
ISO 400

PIGEON

Photos can be found anywhere; the key is to look all around your environment, up and down, left and right, and not just straight in front of you at eye level. There's something about a very formal statue of a great man with a pigeon on his head that I find very appealing. Perhaps it's the iconoclast in me! However, I wouldn't have seen this photo, had I not looked up.

Glossary

Aberration An imperfection in the photo caused by the optics of a lens.

AE (autoexposure) lock A camera control that locks in the exposure value, allowing a photograph to be recomposed.

Angle of view The area of a scene that a lens takes in, measured in degrees.

Aperture The opening in a camera lens through which light passes to expose the CMOS sensor. The relative size of the aperture is denoted by f-stops.

Autofocus (AF) A reliable through-the-lens focusing system allowing accurate focus without the user manually turning the lens.

Bracketing Taking a series of identical pictures, changing only the exposure, usually in half or one f-stop (+/-) differences.

Buffer The integral memory incorporated in a digital camera.

Cable release A device used to trigger the shutter of a tripod-mounted camera at a distance to avoid camera shake.

Calibrator A device used to measure the output of digital imaging equipment. A profile will then be created that can be used by other equipment to ensure consistent color.

Center-weighted metering A way of determining the exposure of a photograph that places importance on the light-meter reading at the center of the frame.

Chromic aberration The inability of a lens to bring spectrum colors into focus at one point.

Color temperature The color of a light source expressed in degrees Kelvin (°K).

Compression The process by which digital files are reduced in size.

Contrast The range between the highlight and shadow areas of a photo, or a marked difference in illumination between colors or adjacent areas.

Depth of field (DOF) The amount of a photo that appears acceptably sharp. This is controlled by the aperture: the smaller the aperture, the greater the depth of field.

DPOF Digital Print Order Format.

Diopter Unit expressing the power of a lens.

Dpi (dots per inch) Measure of the resolution of a printer or scanner. The more dots per inch, the higher the resolution.

Dynamic range The ability of the camera's sensor to capture a full range of shadows and highlights.

Evaluative metering A metering system whereby light reflected from several subject areas is calculated based on algorithms. Also known as Matrix or Multi-segment.

Exposure The amount of light allowed to hit the digital sensor, controlled by aperture, shutter speed, and ISO. Also, the act of taking a photograph, as in 'making an exposure.'

Exposure compensation A control that allows intentional over- or underexposure.

Extension tubes Hollow spacers that fit between the camera body and lens, typically used for close-up work. The tubes increase the focal length of the lens and magnify the subject.

Fill-in flash Flash combined with daylight in an exposure. Used with naturally backlit or harshly side-lit or top-lit subjects to prevent silhouettes forming, or to add extra light to the shadow areas of a well-lit scene.

Filter A piece of colored, or coated, glass or plastic placed in front of the lens.

Focal length The distance, usually in millimeters, from the optical center point of a lens element to its focal point.

fps (frames per second) A measure of the time needed for a digital camera to process one photo and be ready to shoot the next.

f-stop Number assigned to a particular lens aperture. Wide apertures are denoted by small numbers such as f/2; and small apertures by large numbers such as f/22.

HDR High Dynamic Range, a technique to increase the tonal range of a photo by merging several photos shot with different exposure settings.

Histogram A graph used to represent the distribution of tones in a photo.

Hotshoe An accessory shoe with electrical contacts that allows synchronization between the camera and a flashgun.

Hotspot A light area with a loss of detail in the highlights. This is a common problem in flash photography.

Incident-light reading Meter reading based on the light falling on the subject.

Interpolation A way of increasing the file size of a digital photo by adding pixels, thereby increasing its resolution.

ISO-E (International Organization for Standardization) The sensitivity of the digital sensor measured in terms equivalent to the ISO rating of a film.

JPEG (Joint Photographic Experts Group) JPEG compression can reduce file sizes to about 5% of their original size.

LCD (Liquid crystal display) The flat screen on a digital camera that allows the user to preview digital photos.

Macro A term used to describe close-focusing and the close-focusing ability of a lens.

Megapixel One million pixels equals one megapixel.

Memory card A removable storage device for digital cameras.

Mirror lockup A function that allows the reflex mirror of an SLR to be raised and held in the 'up' position before the exposure is made.

Noise Colored photo interference caused by stray electrical signals.

Open-Source Software created by unpaid volunteers that is often free to use.

PictBridge The industry standard for sending information directly from a camera to a printer, without having to connect to a computer.

Pixel Short for 'picture element'—the smallest bits of information in a digital photo.

RAW The file format in which the raw data from the sensor is stored without permanent alteration being made.

Red-eye reduction A system that causes the pupils of a subject to shrink, by shining a light prior to taking the flash picture.

Resolution The number of pixels used to capture or display a photo.

RGB (red, green, blue) Computers and other digital devices understand color information as combinations of red, green, and blue.

Rule of thirds A rule of thumb that places the key elements of a picture at points along imagined lines that divide the frame into thirds.

Shutter The mechanism that controls the amount of light that reaches the sensor by opening and closing.

SLR (single lens reflex) A type of camera that allows the user to view the scene through the lens, using a reflex mirror.

Soft-proofing Using software to mimic onscreen how an image will look once output to another imaging device; typically this will be a printer.

Spot metering A metering system that places importance on the intensity of light reflected by a very small portion of the scene.

Teleconverter A lens that is inserted between the camera body and the main lens, increasing the effective focal length.

Telephoto A lens with a large focal length and a narrow angle of view.

TTL (through the lens) metering A metering system built into the camera that measures light passing through the lens at the time of shooting.

USB (universal serial bus) A data transfer standard, used by most cameras when connecting to a computer.

Viewfinder An optical system used for composing, and sometimes for focusing the subject.

White balance A function that allows the correct color balance to be recorded for any given lighting situation.

Wide-angle lens A lens with a short focal length and consequently a wide angle of view.

Useful web sites

General

Digital Photography Review
Camera and lens review site
www.dpreview.com

flickr
Photo sharing web site with a large userbase
http://www.flickr.com

David Taylor
Landscape and travel photography
www.davidtaylorphotography.co.uk

Photography Publications

Photography books & Expanded Camera Guides
www.ammonitepress.com

Black & White Photography magazine
Outdoor Photography magazine
www.thegmcgroup.com

Equipment

Adobe
Photographic editing software such as Photoshop and Lightroom
www.adobe.com

Apple
Hardware and software manufacturer
www.apple.com/uk

Canon
Camera & lens manufacturer
www.canon.com

Nikon
Camera & lens manufacturer
www.nikon.com

Pentax
www.pentax.com

Sony
Camera & lens manufacturer
www.sony.com

Olympus
Camera & lens manufacturer
www.olympus-global.com

Panasonic
Camera & lens manufacturer
www.panasonic.com/

Sigma
Camera & third-party lens manufacturer
www.sigmaphoto.com

Index

A
8 bit versus 16 bit 15
abstraction 60–61
adjustment layers 86–87
adults 143–145
aging photos 110–111
Alien skin 92–93
animals 108
aperture 38
architecture 44, 53, 62–63, 102,
 158–161, 182–183
attachment, filters 30

B
balance 56
barbed wire 71
Bayer sensors 14
bit depth 15
 scanners 28
blue adjustment 12
borders 136–137
bridge cameras 24
bridges 102
brightness 82
Burn tool, Photoshop 85

C
cameras 23–25
 infrared 126–127
 sensors 14–15
capturing the moment 66–67
cell phones 25
center-weighted metering 45
Channel Mixer 80
Cheviot Hills 18
children 142

close-up 74
clouds 13, 32, 36–37, 151
coated papers 181
color 10–12, 72, 120–121
 subtraction 121
 to black & white 76–97
colored filters 31
compact cameras 24
composition 54–75
 abstraction 60–61
 concepts 56–57
 focus 62–63, 70–71
 framing 64–65, 73
 keeping it simple 68–69
 photo shape 58–59
 repetition 62–63
 still life 162
computer programs, see software
connection
 printers 168, 172–173
 scanners 29
contrast 48–49
 Photoshop 82
conversion to black & white
 76–97
cropping 58–59
Curves tool 84
cyanotypes 114–115

D
decisive moment 66–67
depth of field 39, 62–63
Desaturation 79
digital grain 104–107
digital soft focus 103
Dmax values 29
Dodge tool 85
droplets 61
DSLR cameras 23
dust 48

E
equipment 21–33
 cameras 23–25
 lenses 26–27
 scanners 28–29
 see also software; special
 effects
evening 160
events photography 154–157
exposure 34–53
 aperture 38
 contrast 48–49
 depth of field 39
 high dynamic range 90
 high/low key 50–51
 histograms 46–47
 metering 44–47
 noise 43
 silhouettes 52–53
 times 40–43
Exposure 3 software 92–93
extreme telephoto lenses 27
extreme wide-angle lenses
 26–27

F
files 15–17
film simulation 104–107
filters 30–33, 98–137
 high dynamic range 91–93
 see also special effects
flash 143
focusing
 depth of field 39, 62–63
 selective 70–71
framing 64–65, 73, 136–137

G
GIMP 96
gloss paper 181

graduated neutral density filters
33
green adjustment 12
gum bichromate 128–131

H
halftone 132–133
high dynamic range (HDR)
88–93
 conversion 90
 filters 91–93
 Photoshop 89–93
high-key photos 50
highlight compression 90
histograms 46–47, 90
human touch 147

I
iconic locations 146
images
 framing 64–65, 73,
 136–137
 print resolution 175–177
 resizing 176
 shape 58–59
 sharpening 177
 see also subjects
incident metering 45
industrial subjects 102, 104
infrared 126–127
inkjet paper 180–181
inkjet printers 168–173
ISO values 42

J
JPEG files 16

K
keeping it simple 68–69
Kilimanjaro 148

L
landscapes 8, 18, 33, 56–57,
 129–131, 134–135, 150–153,
 169
layers, Photoshop 86–87
leading lines 56–57
lenses 26–27, 159
levels in Photoshop 83
light
 contrast 48–49
 sensors 14
 still life 162
 theatrical 18
 wavelengths 11
Lightroom 95
lith printing 134–135
long exposures 41–43
low-key photos 50

M
matte paper 181
metering 44–47
mist 48
movement 66
multi-segment metering 44–45

N
negative photograms 117
neutral density filters 33
noise 43
 gum bichromate 128–131
 simulation 104–107

O
open-source software 96

P
paper 180–181
people 66, 70, 103, 105–107,
 128, 142–145, 159

photocopy effect 132–133
photograms 116–119
photographic paper 181
photos
 framing 64–65, 73, 136–137
 print resolution 175–177
 resizing 176
 shape 58–59
 see also subjects
Photoscape 96
Photoshop 78–93
 Alien skin 92–93
 Black & White 81
 Channel Mixer 80
 Desaturation 79
 filters 91–93
 high dynamic range 89–93
 layers 86–87
 levels 83
 local adaptation 90
 printing 174
 special effects 101
 textures 122–123
 tonal adjustment 82–85
Photoshop Elements 94
Pictbridge 172
Piknik 97
Pixlr 97
polarizing filters 32–33
positive photograms 118–119
pre-visualization 13
printing 166–185
 inkjet printers 168–173
 paper 180–181
 Photoshop 174
 preparation 173
 proofing 179
 resolution 175–177
 sharpening 177–178
printing effects 132–133

programs *see* software
proofing prints 179

R
RAW files 15–17
red adjustment 12
red apples 10–11
reducing noise 43
repetition 62–63
resolution
 printing 175–177
 scanners 29
rule of thirds 56

S
scanners 28–29
sculpture 9, 149, 184–185
seasons 150–151
selective focus 70–71
sensors 14–15
sepia 108–109
sharpening 177–178
short exposures 41–43
shutter speed 40
silhouettes 52–53
simulated grain 104–107
sky 13, 32, 36–37, 151
smart phones 25
smart sharpen 178
social photography 154–157
soft focus 102–103
soft proofing 179
software 76–137
 Elements 94

Lightroom 95
open source 96
Photoshop 78–93, 101
special effects 98–137
web-based 97
solarization 112–113
special effects 98–137
 Alien skin 92–93
 aging 110–111
 borders 136–137
 color splashes 120–121
 cyanotypes 114–115
 grain 104–107
 gum bichromate 128–131
 infrared 126–127
 lith printing 134–135
 photograms 116–119
 printing 132–133
 sepia 108–109
 soft focus 102–103
 solarization 112–113
 split-toning 124–125
 textures 122–123
 toning 108–115
splashes of color 72, 120–121
split-toning 124–125
spot metering 45
squint test 13
standard lenses 27
still life 162–165, 184–185
streetlights 53
subjects 138–165
 architecture 44, 53, 62–63,
 102, 158–161, 182–183

clouds 13, 32, 36–37, 151
events photography 154–157
industrial 102, 104
landscapes 8, 18, 33, 56–57,
 129–131, 134–135, 150–153,
 169
sky 13, 32, 36–37, 151
social events 154–157
still life 162–165, 184–185
travel 146–149
water 57, 60–61, 75, 135
Sumopaint 97
symmetry 56

T
telephoto lenses 27
textures 122–123
 grain 104–107
time of day 147, 158
tonal values 11–12
toning effects 108–115
 Photoshop 82–85
 split 124–125
travel 146–149
trees 52

W
water 57, 60–61, 75, 135
wavelengths 11
weather 151
web-based software 97
web sites 97, 189
weddings 155
wide-angle lenses 27